GARDNER WEBB COLLEGE LIBRARY

Modern Artists                                                                    Tàpies

Harry N. Abrams, Inc., Publishers, New York

Věra Linhartová

# Tàpies

*Series Editor: Werner Spies*

*Translated from the French by Anne Engel*

*Standard Book Number: 8109-4426-X*
*Library of Congress Catalogue Card Number: 72-2888*

*All rights reserved. No part of the contents of this book may be reproduced*
*without the written permission of the publishers, Harry N. Abrams, Inc., New York*
*Copyright 1972 in Germany by Verlag Gerd Hatje, Stuttgart*
*Printed and bound in West Germany*

ND
813
T3
L5613

'It might be more effective to show a heap of sand containing an infinite number of grains, each of them equal in size, than to make any amount of speeches about human equality', says Tàpies. This at once introduces a major concern of his painting: the immanence of all ideas in the life of *matière* (matter). Like all attempts to define a painter's *oeuvre* by appealing to his own words, however unpretentious they may sound, this quasi-definition courts inadequacy. Nevertheless, it emphasizes the difference between the expressions 'in the life of *matière*' and 'in the *matière*': a distinction which may be useful later in this essay.

Tàpies is a monotonous painter who never repeats himself. His early work placed him straight away in a domain entirely his own, which he was to explore after a few years spent reconnoitring the waste lands opened up by his contact with different centres of intellectual concentration and influence of the time. The revelation which came to him about 1953 made him return to his old, instinctive groupings. These he resumed more with the negative knowledge of those areas which he had exhausted and would not continue to pursue than with any very clear idea of what his next step would be. The renewal of plastic language which he achieved during the following years, though not without precedent or parallel among his contemporaries, seems nevertheless to have evolved from a coherent vision of the world, peculiarly his own from the start, rather as a mathematician of genius formulates his preliminary hypothesis with the blind certainty of intuition and then merely clarifies and demonstrates it, step by step.

In Tàpies's paintings the world is not represented by images, nor by symbolic objects, those substitutes for the externality of objects, independent of the painter's vision and experience. It is immediately present in the range of the materials used, in the scratching away which reveals the canvas or the stretcher of the painting, in the accumulation or distortion of the paint, of the grain of sand, of the marble dust. It may happen that the *matière* in movement allows contours, phantom objects, even figures to appear. It is quite free to do so, provided that the objects emerging at the surface of the *matière* are of the same nature and order as the vortices and the lines of force, the patches of paint, fingerprints, attempts at writing, the cuts—and hollow spaces where the *matière* is absent. No form the *matière* assumes in passing dominates the others, the hierarchy inherent in nature is entirely abolished; all forms, equally, are only transformations, potentialities successively and unceasingly taken up and abandoned.

These comments may seem valid only in the case of the works of the mature painter, those later than the period of searching between 1948 and 1954—the so-called 'literary' or 'mystic' period. What is most striking about the paintings of this intermediate period is their theatrical aspect. In the detour, embarked upon after the first collages and assemblages, after the first contacts with

5

raw, inert *matière*, and leading towards what was later to become Tàpies's dialogue with the surrounding world, another fundamental experience crystallized. This experience, even though he abandoned its most obvious, plastic, manifestations, was nonetheless to provide the essential foundation for the painter's present conceptual vision. What he sees, then, and what he expresses in the spatial construction of his paintings is not a conventional illusionism, adapting itself to the fiction of three-dimensional space. On the contrary, illusion is unveiled and held out as such, illusion one and undivided: nocturnal, lunatic spaces inhabited by phantoms; paraworlds; scenery for a stage from which the *dramatis personae* are absent, or, more precisely, where only the ghosts of a Germanic, Nordic, Wagnerian mythology may pass. The theatre is another world whose proper role is that of the *spectaculum mundi*, to hold a mirror to that world of appearances which is our own. The canvas, therefore, is not a place for representation but for observation (or contemplation, as Tàpies would say) of events beyond the theatre's range, or within vision itself.

The actor in this *mise-en-scène* of the world, creative man, inevitably crosses to the other side of the footlights—Tàpies at the very moment of creating his painting, the rest of us at the moment when we look at it. This eccentric anthropocentrism—dissolving the image of man as subject of the painting and re-establishing a dialogue between man and man through the image/spectacle of the world which they have in common (thus replacing the archaic and sclerosed relationship of author/image-as-representation/spectator) corresponds exactly to the present state of our knowledge in an apparently quite different domain: that of the natural sciences. Since Heisenberg everyone (the painter as much as anyone) has been supposed to know that the question of the objective reality of the things around us, whether in daily life or in another context, may no longer be raised or, at any rate, not in the same way.

If we accept—as far as the human sciences are concerned—that the image resulting from a process of observation does not acquaint us with the object's real nature, but only with the level of knowledge of it gained by that same process, then, in other domains, or even in daily life (which is our primary field of observation), it is impossible to pretend that this discovery has not been made. The world changes as our image of it changes. The painter should be aware of this even if he has never even heard the name of Heisenberg. The parallel between the scientists' and the artists' intuitions is indeed a most astonishing thing in a world otherwise short of surprises. 'The image of Nature always presupposes man. We must accept as evident that we are not spectators but actors in life's theatre'. One might almost attribute this remark to Tàpies, but in fact it was made by Niels Bohr.

Tàpies's first works are about the simplest things in life—and death—and range from hermetic meditations to the exaltation of a piece of paper or rope. The maturity of this young painter who was only twenty-two years old at the end of the war, but who nevertheless unhesitatingly found his bearings in the renewed artistic life, may appear surprising. It is, however, perfectly comprehensible if we take account of the paradoxical fact that periods of oppression, of isolation, even of terror, may act as a stimulus to the awakening of an artist's consciousness. Under such circumstances, favourite authors take on the character of a personal discovery, a concert becomes a shattering event, odd magazines and catalogues of some exhibition of modern art, when contrasted with the aridity of official art, make for a rapid grasp of what is lively and essential. Against a background of material and cultural penury, words, colours, tones are thrown into relief and are seen in a very special light, as portents of another life. Such were the years of Tàpies's apprenticeship. From 1934 onwards, he became acquainted with contemporary art through magazines published in Barcelona, notably *D'Aci i D'Alla* directed by Joan Prats and José Lluis Sert. But it was chiefly between 1940 and 1942, during a long convalescence, that he began to read widely and to choose those writers who were to influence him: Dostoyevsky, Nietzsche, Poe, Ibsen, Unamuno— to which must be added *The Book of Tea* of Okakura Kakuzo, read at the age of fifteen, which opened up the Oriental world to him. A characteristic trait of Romantic origin is already in evidence: a nostalgic longing for distant lands, first the Northern countries (a nostalgia familiar in Catalan culture), then those of the East. We must also bear in mind the Wagnerian cult, established in Barcelona since the end of the century and well-entrenched in Tàpies's family circle, and of course, the legacy of Dada and Surrealism which, in Spain as everywhere else, continued to uphold its resolutely modern and subversive aspect against the prevalent current of conformism. As for art schools, Tàpies succeeded in avoiding them, apart from a two months' attendance at the Academy of Drawing in Barcelona in 1944. He had, however, a certain affinity for the ideas of Mathias Goeritz (the author of the Manifesto of emotional architecture who was later to have such a singular career) and the work of Goeritz's School of Altamira, even though he only met this architect and sculptor very occasionally during Goeritz's brief stay in Spain. In the background, of course, was the shadow of Gaudí, omnipresent in Barcelona. But it was chiefly Goeritz's interest in rock paintings, their origins lost in the night of time, which probably attracted Tàpies to him; for, on closer study, do not these rock paintings, these patches of ochre, black and blood-red which hug the uneven surface of the rocks in the cave of Altamira, and the legend of their magical effects have a distant kinship with Tàpies's 'mural' paintings, always bordering on quasi-relief, always ready to disappear, to merge into the wall to which they cling?

Indeed, it is walls that the painter proceeded to transpose in his first completed canvases. Tàpies, intellectually mature, begins to paint like a child so that, perhaps unconsciously, he is able to repeat philogenetically the whole of man's pictorial experience in his own work. Two paintings of 1947, *Painting* and, even more, *Figure on Burnt Wood* (17, 18), are the drawings of a child tracing with his finger the elementary outlines of a human figure, basing himself instinctively on the primary geometric forms of the circle and the straight line. The second of them also reminds one of a later remark by Tàpies: 'I saw my mother crying with hunger during the bombing of Barcelona'. The simplest elements of life and death are involved: walls with graffiti and *objets trouvés* which may be found in the street—not Duchamp's ready-mades (though the echo of his gesture is undoubtedly there) but refuse, shreds of old newspapers, finds scavenged from rubbish dumps. Tàpies's attitude towards the *objet trouvé* differs from that of Duchamp in that, while the latter extracts an object from its natural surroundings in order to give it a surprising, emotional value by isolating it from its context, Tàpies incorporates his bits of paper, string or pieces of wood into an emotional story which he tells himself. The collage *Newspaper Cross* (19) is significant from several different points of view. The introduction of a piece of newspaper into a painting is no longer the striking novelty it had been in Braque's or Picasso's collages; the novelty here lies in the internalized function of the raw material. The cross is cut out of an obituary notice from some daily paper. This form alone epitomizes the innumerable small announcements which pass unnoticed in newspapers, but which, however, conceal entire lives that have recently come to an end. Thus, any individual drama can be traced by a single sign; numberless beings merge into one. The sign of the cross, or, rather, the shape of the cross was to continue to appear in Tàpies's work, but free of the overt significance it assumed in this collage. What Tàpies has done is precisely to eliminate all significant overtones, thus reducing the cross to the level of a phenomenon, of pure appearance.

The cross is, in fact, one of the simplest and most familiar of shapes; to produce it, it is enough to fold a sheet of paper in two, repeat and then unfold the paper, or to tie a parcel with string, as in *Perpendicular Cords* (39). It is part of the alphabet, particularly in the letters X and T, e.g., *Matière on Canvas and Collage* (46); it can also be the signature of an illiterate, the simple sign of his presence. In *Grey with Black Cross* (34) it is little more than the shadow projected on a wall, or a piece of cloth, covered with unfinished and scarcely decipherable incisions. Ultimately, the cross assumes a purely negative shape. In *Four Boards* (38) it is barely traceable, the width of a crack between damaged edges, and becomes the vacuum between plates of opaque *matière*, the opposite of an object. Finally, it is quite simply the wooden stretcher behind the image, as in *Reversed Canvas* (44).

8

In 1948 Tàpies was involved in the founding of the magazine *Dau al Set*, inspired by Joan Brossa, poet and playwright, and a group of young writers and artists bearing the same name formed itself around the magazine. It was at this point, in the atmosphere of lively discussion and interaction which accompanied the group's activities, that the influence of Surrealism, hitherto latent, manifested itself. The change in Tàpies's plastic vocabulary during the years 1948–53 can be traced back to Miró in particular, but also to Klee and Ernst and, in rare cases, even to Magritte. This influence, however, became integrated into a clearly outlined though still uncharted world. The most striking innovation is the breaking-up of space, the fictitious third dimension within a painting. This concession to normal optical illusion is, however, an episode without sequel in Tàpies's work.

In opposition to Miró's vivid universe, with its pure colours and subjects born of an imagination given free rein, a painting by Tàpies is nearer to mediumistic drawing with its haziness, its ambiguous figures radiating an unknown force and its thin, hesitating lines which seem to come from afar to brush the surface of the painting and disappear again. In the background of all these pictures is a luminous centre illuminating the phantasmal scene—the moon, a half-open door, a small suspended rectangle, an incandescent flower—for it is light that creates this illusory space. Even the dream world so dear to Surrealists which—like another world finally become true and real—they believe they capture in their paintings, does not escape the profound vision of Tàpies. But for him, it is only another illusory world, neither more nor less real than the world of everyday objects. This detour was, therefore, really necessary in order that Tàpies might one day be able to reveal the nature, at once apparent and fleeting, of what we normally call reality.

*Closed Room* (20), with its magic flowers, roots shaken by the wind and petals aflame, and with an impassable staircase and a dematerialized ladder both climbing towards a luminous opening, relates to a nocturnal experience radically different from that of the Surrealists. A curious detail is the outline of spectacles, the affirmation of an alert, invisible observer. The same object is found later in *Four Red Bars* (50) and also in one of the most recent paintings, *Spectacles*, where it covers the whole surface and becomes the only subject.

Even more than *Closed Room*, *Green on Dark Brown* (21) is a cosmogonic vision, virtually a narrative image of the origins of the world. Creative forces emerge in concentric circles from the primitive nebula, and out of these arise two opposing beings, two demiurges, perhaps; on the left, illuminated by an uneven light, is a curious creature, half plant and half animal, its right hand stretched

9

towards an even more rudimentary figure—a human embryo; on the right is an obscure figure, ambivalent in its reversibility, the spirit of negation. Below, near the bottom edge, is a squared-up perspective—the favourite subject of Quattrocento painters, who employ it with the virtuosity of men astonished by their own knowledge—a perspective which disintegrates before the perfect geometry of the cosmic circles.

Yet another element, writing, appears in the paintings of this period. It is integrated, as a sign among other signs, with other, more or less figurative, hieroglyphs (as in the painting *Mudrc* of 1949).[1] Though the several characters are at times distinct, the message remains indecipherable. This element is further evolved later in 'runic' paintings on the one hand, and on the other in variations on several letters of the alphabet—M, X and T in particular—where it links up with the subject of the collage *Newspaper Cross*.[2] The recurrence of the same elements in the work of Tàpies of different periods and their interpenetration has parallels in music, and this analogy is still apter later on, when a veritable orchestration of *leitmotifs* develops.

Tàpies's predilection for Wagner's music and the fascinating atmosphere of Nordic mythology underlies a number of paintings, mostly dating from 1950, notably *The Trickery of Wotan* (23) and the other panel of the same diptych, *The Sorrow of Brunhilda* (not reproduced). We can better understand this source of inspiration by looking at the history of culture and art in Catalonia where, as elsewhere, we find a current of ideas, rooted in Symbolism and in what is called in Catalonia *el modernismo* (Art nouveau), characterized by a nostalgia for the North, comparable with the attraction exerted by Italy on the northern countries and on the nineteenth-century Romantics. This may be motivated by the attraction of opposites, but also by the pressing need for the complementary, for balance, for universality. Towards the end of the century, the critic G. Zanné, put the question thus: 'What is it which prevents us Southerners from identifying with Nordic concepts?'[3] And more than half a century later Tàpies replies: 'The North attracts me … the Nordic character seduces me'.[4] This unsatisfied, unsatisfiable desire to live under other skies while remaining in the place of one's birth, recalls a sentence from *The Book of Tea* defining the art of living in the world (the Zen) as 'the art of feeling the polar star in the southern sky'. Here then is the current interpretation of man's instinctive grasp of the world's fragile unity: no longer deluded by the possibility of relegating 'elsewhere' a better world to come, but with the urgent desire of embracing simultaneously all that is authentic and spontaneous in the present world.

The cult of Germanic music, literature and philosophy has undoubtedly had a marked influence on the plastic arts. In 1901, once

more at the initiative of G. Zanné, the Wagnerian Association of Barcelona was founded, and the interior of its premises was designed by Adrian Guál, who included panels painted with motifs from Wagner's operas. There are other precursors, too, with less immediate influence on the themes of Tàpies's paintings, but of considerable importance in terms of his feeling for *matière*. Nicolás Raurich, who was undoubtedly nearest to Tàpies in spirit, painted, among other works, the startling *Luna llena* (c. 1900),[5] a nocturnal land-scape seemingly woven of black light, built up with coloured *hautes-pâtes* worked virtually in relief. There was also Gaspar Homar, who was influenced by the arts and crafts movement then at its height, and who introduced marble into the marquetry of his figurative panels in order to distinguish the visible parts of the body—faces and hands. These reliefs project from the flat surface of the surround-ing wood evoking the immediate and almost carnal presence of female dream silhouettes. Other influences, more distant in time, are the precious stones used for tears and drops of blood in Catalan Baroque sculpture, or the clothes and hair of the statues carried in processions, which emphasize the sacral quality for centuries attributed to material in its raw state in Catalan art.

Thus Tàpies's digression into 'Wagnerian' themes in painting fits in well with the tradition of Catalan modernism. *The Trickery of Wotan* is in fact merely one stage in the continuous process of peeling away successive layers of the world of appearances. In a deep space, on a stage illumined by footlights shining with all the colours of the spectrum, volumes and planes are superimposed in impos-sible, unreal conjunctions. A curtain, a tent, a cloth are swollen by an invisible breath and seem to conceal within their folds that mocking divinity who is the hero of this tragi-comedy. Again, one is put in mind of *The Book of Tea*: 'How can one be serious with the world when the world is itself so ridiculous?' For Pompeyo Gener, Symbolist poet and advocate of *la autenticitá* and *la naturaleza*, essential qualities of the new art, Wotan himself was 'the incarnation of the incomprehensible—that is to say, of movement, force and action'.[6] In this notion, so near to Tàpies's own vision of Wotan as both magician and comedian, is prefigured what was later to become the major preoccupation of Tàpies's painting: to make visible the life of *matière* stripped of any apparent subject, to represent an impersonal force which pierces and dissolves solid objects. Wotan is but one of its mythical personalizations. The 'trickery' (*escamoteix* —conjuring or sleight of hand) is indeed a mischievous trick played on us by objects and by the surfaces of things when they pretend to an ultimate reality; they are like so many traps laid for the observer who limits himself to superficial, habitual means of perception. But the trap exists also for the painter. Traditional subjects, literary anecdote, narrative, ideology and morality are latent in these paintings of 1950. This dichotomy was not resolved, it was an impasse from which Tàpies was only to extricate himself by going back

to the beginning and starting out again in search of his own inalienable line of development, while retaining a memory of this apparently fruitless experience.

'Others have failed because they sang but of themselves. I left the harp to choose its theme, and knew not truly whether the harp had been Peiwoh or Peiwoh were the harp'. Thus the celestial monarch is answered by the prince of harp players, Peiwoh, whose skill not only made the hitherto silent instrument sing but also moved the whole of Nature to follow the inflections of his song.[7]

When Tàpies abandons the predetermined subject, whether external and supposedly objective or purely internal and derived from the emotions or knowledge, his instrument, painting, finds itself in a void. This is the familiar *tabula rasa*, the point of departure for modern and contemporary art. It is also the void of mystical experience, the soaring and anguished apogee of thought before it falls back to the earth once more. It is at this moment, about 1953 in chronological terms, that Tàpies himself becomes the instrument at one with the *matière* he uses. From then on, reality becomes merely that which takes form in the course of the painter's interaction with an amorphous force. Countless artists, reaching the same point, escape by means of increasingly rigid geometrical rules, or resort to a renunciation of informality and the spontaneous gesture. Tàpies, however, is the painter of the happy medium or, better, of constant adjustment.

*Ochre-grey* (24) is on the edge of this metamorphosis, and the transition is worked out in a few paintings in which the influence of Paul Klee is still apparent; *Epicurean Meditation* and *Yellow and Violet* of 1953[8] are planes and surfaces of luminous and transparent wires. But what in Klee is merely pictorial technique becomes in Tàpies the imprint, the direct introduction, of the *matière*. The surface of the painting becomes a membrane ready to register all kinds of vibrations, from virtually imperceptible movements to deep searings, from the blurred contours of nascent objects to the dissimulation or effacement of obstinately recurring visual themes. The *matière* of the paintings changes; instead of paints, powdered marble now predominates—the raw substance of ancient reliefs, reduced to minute particles and bound with synthetic media. This substance, simultaneously dense and fluid, lends itself particularly well to its purpose, mid-way between painting and relief, of preserving the traces of fleeting happenings and maintaining the delicate balance of materialized reality.

*Swirling Sand* (26) marks the point at which this new painting crystallized: a concentric, circular movement, not reducible to any geometrical form or natural movement, though it would seem to follow the outline of one. A whole series of 'sandy' paintings follows, 12

monochrome or virtually so, their semi-penetrable surfaces allowing barely discernible dematerialized objects to appear, among them *Clear Sand* (31), *Brown Bed* (43), *White with Triangle* (56) or, ultimately, *Circle of Cord* (61) and *Riz* (of which Tàpies was also to make an engraved version, in high relief on white paper).

In contrast to these almost monochrome works, calm, soft and seemingly as inexpressive as the dialogues in Chekhov's plays,[9] another element—at times in conflict with the painfully achieved harmony—constantly recurs in Tàpies's paintings. This is the *tache* (blot or stain): a finger dipped in red and wiped on the canvas, the careless mark of the brush attempting to conceal what was there before, or blobs, some in the shape of a cross, others spreading in a circle. These stains are never straightforward aesthetic manifestations but always suggest the presence of a living being—a human trace, alternating with the imprint of paws, indecipherable writing, cracks and slashes. If forces exist which compel objects to assume a given form, there are also others which strive towards their atrophy, erosion and disintegration, and nothing remains of this movement from inception to decline—except paintings, frozen images of fleeting moments in time. In this vital process, this unalterable cycle which everything in life without exception undergoes, no moment outweighs any other, there is no ideal or even standard form, and no unflawed beauty. The process of erosion alone is worthy of interest, the constancy of the semi-complete and incomplete in things.

*Three Stains on Grey Space* (27) forms the beginning of a series which continues with *Grey with Two Black Spots* (32) and, via many variations on the same theme, reaches its apogee in *Painting on Wood* (36, 37), a painting remarkable in several ways. In this work (which is double-faced like a medallion), a stain appears in a spot on the reverse exactly corresponding to the spot on the obverse which seemed reserved for it—the empty angle of a form which seems vaguely anthropomorphic, but which might equally well be an inverted letter M or even the truncated half of another motif frequent in Tàpies's work: the set-square. The painting's reversibility brings us back to the notion of arrested time, to the harmonious confusion of before and after. Furthermore, it presages the *Reversed Canvas* (44)[10] which, this time, presents the viewer with a single face—but the one which he habitually is not prepared to consider as part of a painting or a work of art. Once again it is a trick of the disillusionist magician: a sudden unveiling of the hidden face of a painting. We recognize once more, executed in a simple and direct manner, the idea of the *spectaculum mundi:* the collusion of the two appearances, of the image and the *matière*. It is a realization, foreshadowed in the Wagnerian paintings of the early fifties, which no longer fears to reveal the nuts and bolts of its achievement.

The set-square, the movable square, the right angle, the plumb-line which indicates the direction of gravity anywhere in space—there are as many axes of symmetry and asymmetry in Tàpies's work as there are building tools. The Chinese painting of the Sung dynasty had two compositional plans: ⊠ (One Corner) and ⊞ (Half).[11] There, the plan was fixed, omnipresent and invisible—the image of Nature's limitless variations on a theme as unchanging as the return of the four seasons. With Tàpies, the very elements of the composition become visible and subject to modification: One Corner, e.g., *Oblique Cupboard Shape* (54) or *Brown and Plastified Matière* (64); the Half, e.g., *Small Brown Relief*, *The Curved Door*, *Matière Pleated in the Shape of a Nut* (57) and also *Two Blankets Filled with Straw* (58) among many others. To make the repertory of geometrical elements more or less representative, we should also mention paintings such as *Triangular Form on Grey* or *Ochre and Greyish Angle on Black*.[12] All these elements which, by dint of infinitesimal displacements, seem to seek their rightful place in the space of a painting[13] never attain the abstract aridity of pure forms. They become transparent by means of stains, cords, numerals, cracks and joints in the contours of furniture and the edges of partitions. They become at the same time projects and instruments, construction components—for it is indeed a matter of construction, or, rather, of a construction in progress: walls, doors, roof, a little straw, parcels tied with string.

Around 1965–66, other elements were added to this universe which already included the working of the *matière* and which had then developed from primitive circles on a sandy surface to the rigidity of a dilapidated wall. For the first time since the consciously child-like drawings of 1944–47, the human body once again asserts itself in Tàpies's paintings, from which it seemed to have been excluded by a kind of iconographic ban. But (let us be precise in our terminology) it is not the human *figure* which thus returns to this universe, which has never ceased to be anthropocentric, even if its focal point had been displaced; it is the *matière* which is literally *embodied* and clothes a figure, which in these circumstances resembles our image of the human body, exactly as it had previously been embodied in the movement of sand, the outline of an object, or a spot of colour. *The Landscape* of 1965,[14] a face/landscape, ambivalently readable as a place, a person and a transformation, is perhaps the most accomplished of a series which contains *Matière Shaped Like a Foot* (51), *Matière Pleated in the Shape of a Nut* (57) and several others; hand, ear, naked torso—dismembered parts of an unidentifiable body which it is impossible to visualize all at once, since the viewer is within it. The spectacles, sign of an invisible observer, also are taken up again at this period, in *Four Red Bars* of 1966 (50) and in *Spectacles*.

Writing, according to Tàpies, is only another aspect of the condensation of the *matière*. It can be engraved or painted (that is to 14

say, it can consist in the subtraction or addition of *matière*) but it always remains linked with the *matière* to the point of merging into it. It is never distinctly legible even if, untypically, it appears to come close to conventional characters. It is chaotic and disordered, as in *Large Grey Painting* (33), where it seems to want to encircle the empty space in the centre of the painting which appears to resist and engulf it as it approaches. This empty, untouchable centre seems to be charged with a force which repels the writing towards the edges of the painting, so that the most marked incisions are found only on the margins; below everything, hastily traced, an X, sign of the cross, signature of an illiterate. *Grey with Black Cross* (34) embodies the same effect, though here the empty space lies diagonally and impels the few barely sketched lines, which deepen into long furrows carved by too heavy a hand, towards the upper left-hand corner; the double sign of the cross is placed very low on the right, in a position which almost oversteps the limits of the canvas.

Writing is also one of the elements and forces which add to the dilapidation of the walls, for at times it is reduced almost to cracks and crumblings, a perforation of the surface, the start of its erosion. Its advent is only transitory; in essence it remains silent or obscure, untranslatable into words. Even if on occasion it becomes legible, if it appears in the painting as writing, for instance as printed characters on glued pieces of paper, it becomes no more explicit. In this case, as in *Matière on Canvas and Collage* (46), it relates only trivialities from yesterday's papers. At times a single isolated character could claim to brush the fringe of significance, but it only reverts immediately to something else: the M body of *Painting on Wood* (36, 37), the H door in *Black Relief on Red Symmetry* (59), the L right angle, the A triangle, etc. At other times, it can only be guessed at 'from the other side', contained within or on the blank pages of a school exercise-book.

In opposition to writing, to what, in spite of everything, we would be tempted to consider a way of expressing an idea, or at least a sign of spiritual activity, the brute mass imposes itself by its silent presence, inexplicable and still more mysterious. This is one of the fundamental constants of Tàpies's work, from his first collages and assemblages onwards, and one which he has never repudiated and only occasionally modified, accenting or diminishing the place it assumes in a painting. Such are wrappings and cardboard boxes tied with string—hidden things, yet objects of everyday life: *White on Board Ground* (42), *Collage of a Plate* (45).

In his most recent paintings, dating from 1969–71, Tàpies returns to the immutable presence of things. Only the moment of choice and the will to distinguish one object rather than another witness the presence of the observer, prisoner of the advancing situation.

*Collage with Sacks* (63), *Matière and Glass* (65), *Gathered Newspapers* (67), *Straw and Wood* (68)—the objects are simply there, and the world of the visible and tangible imperceptibly encroaches on the critical sense, on the painter's sense of observation. The painter abandons himself to this world, to the point of rejecting the ordered severity of the canvas, with its clearly defined bounds which, even if he has constantly questioned them, he has so far always respected. A stained cloth, pierced by a bamboo cane, signed Tàpies; is it wisdom or is it a capitulation—another impasse? In 1948 Joan Brossa said of Tàpies that he was 'a prisoner of the things to come'.[15] But it is also essential to know that 'the future is beyond us'.

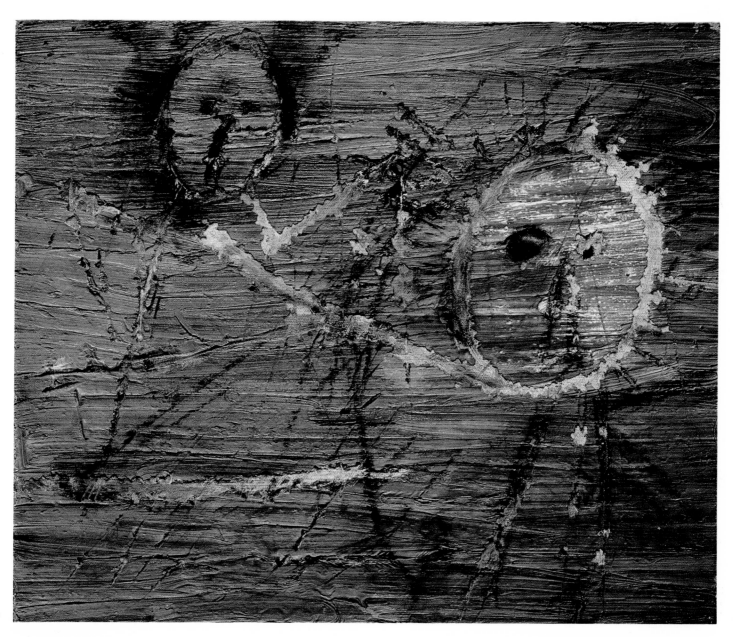

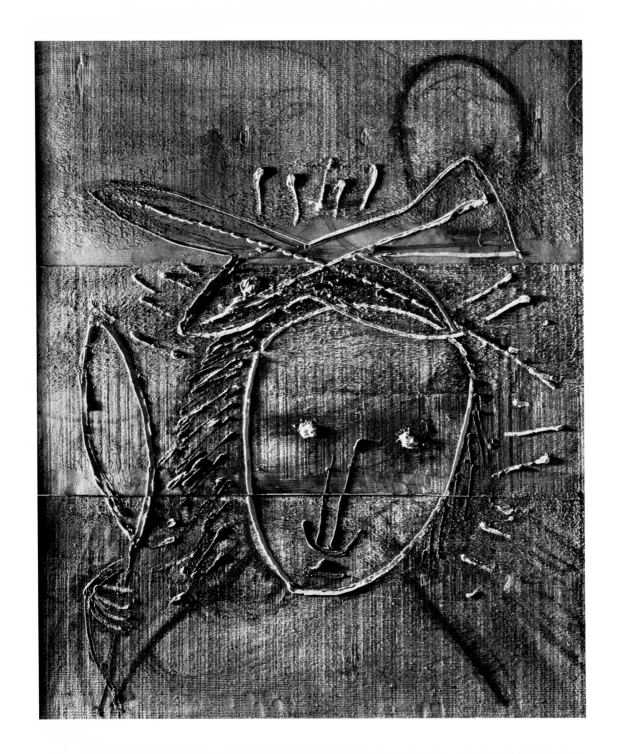

18

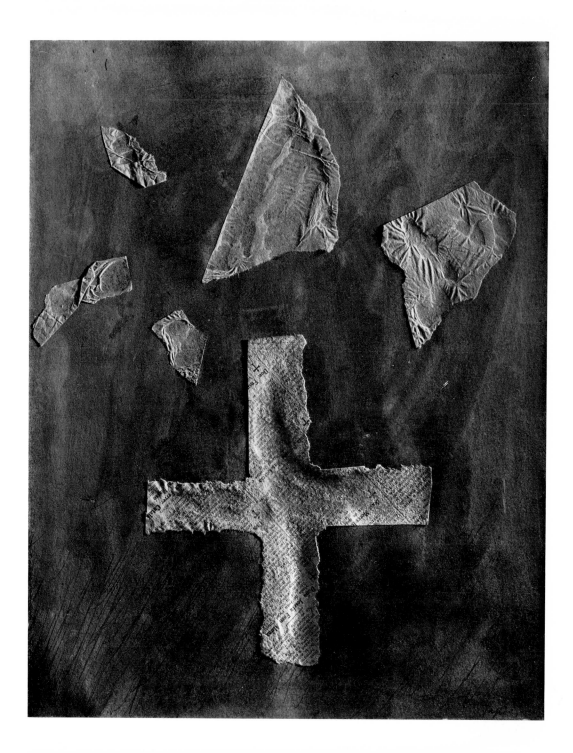

Closed Room, 1949

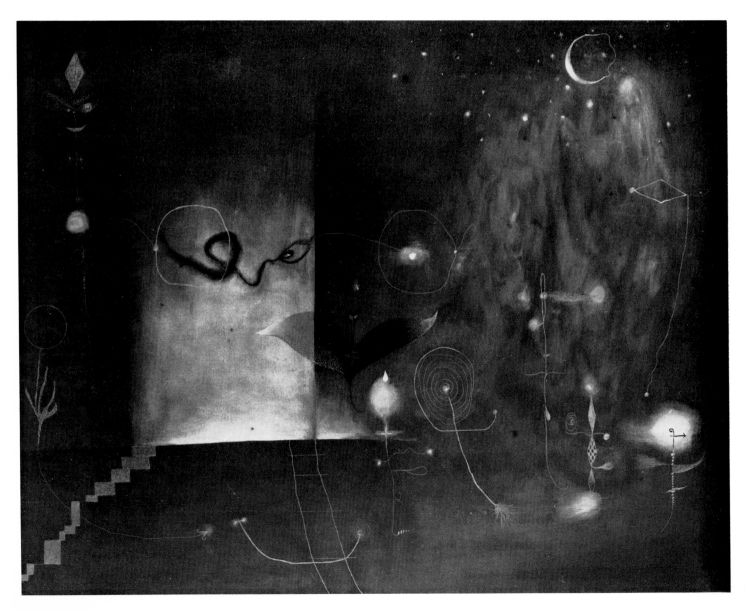

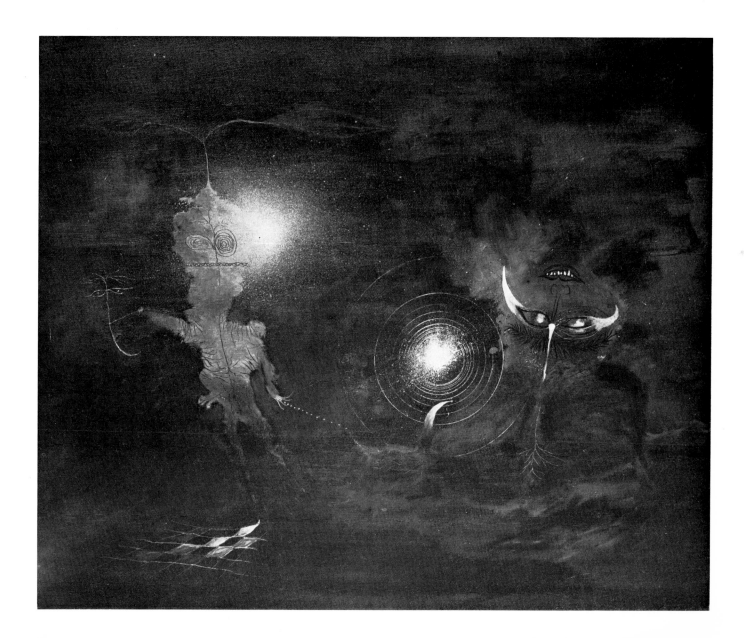

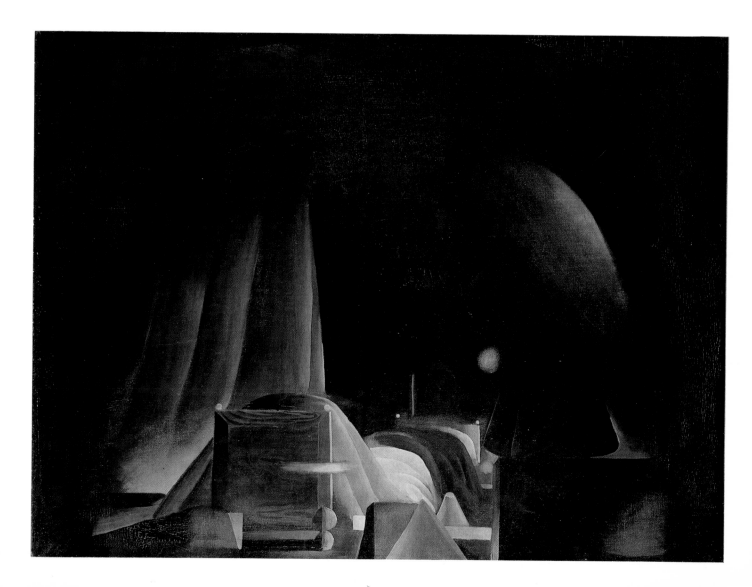

Ochre-grey, 1953

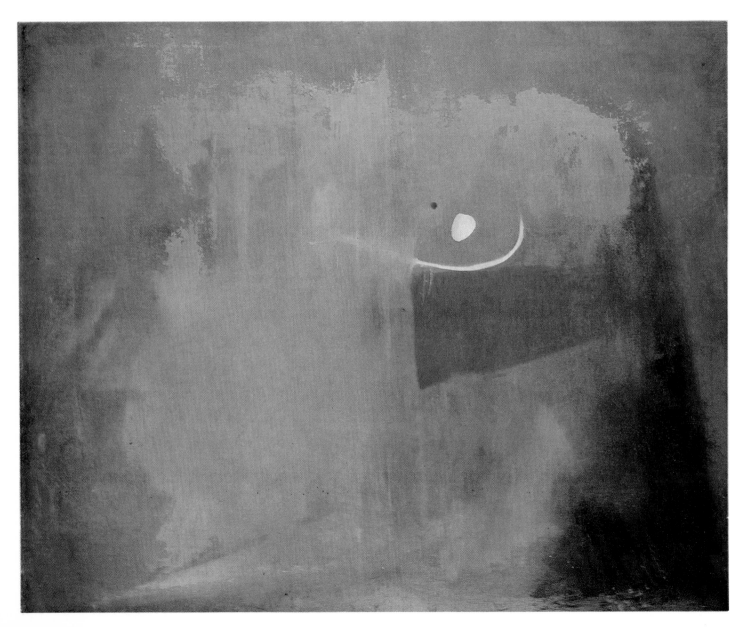

Still-life in Sirefala, 1950

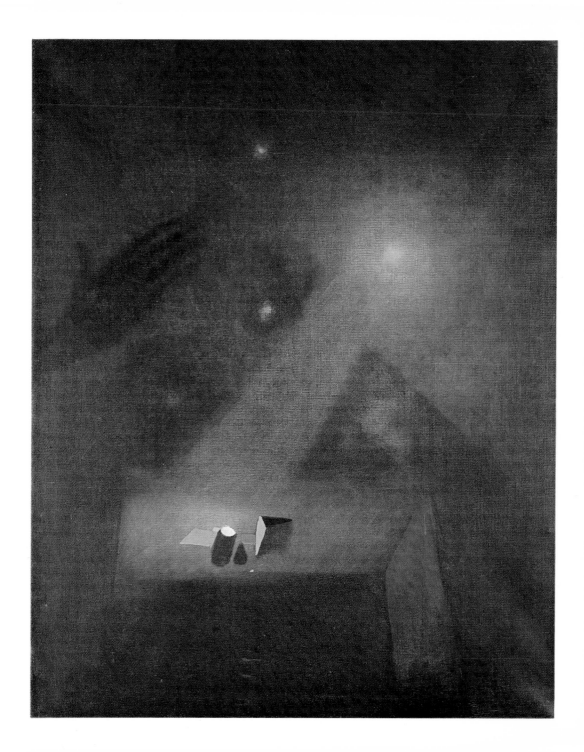

Swirling Sand, 1955

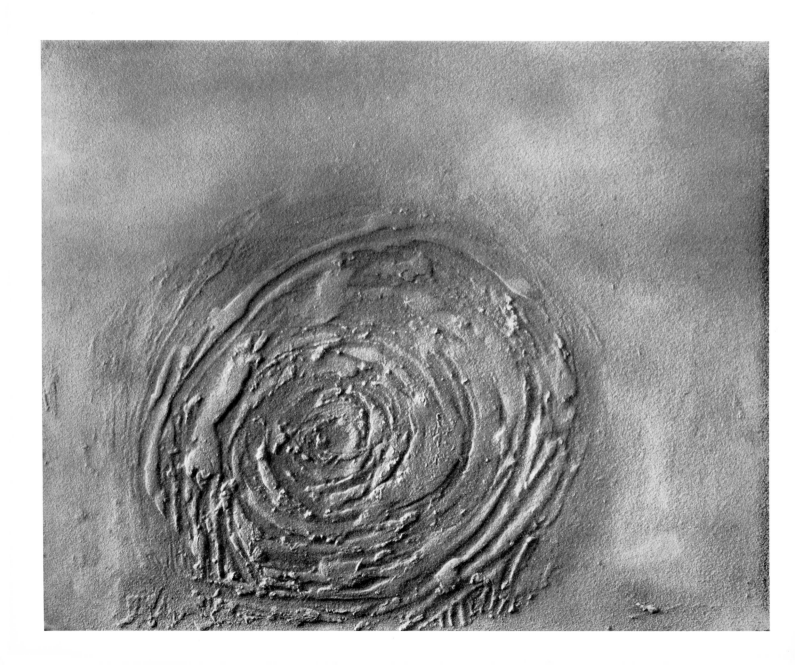

Three Stains on Grey Space, 1955

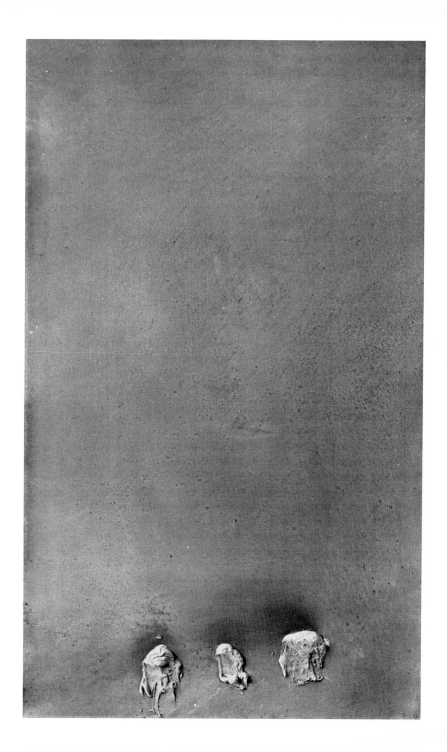

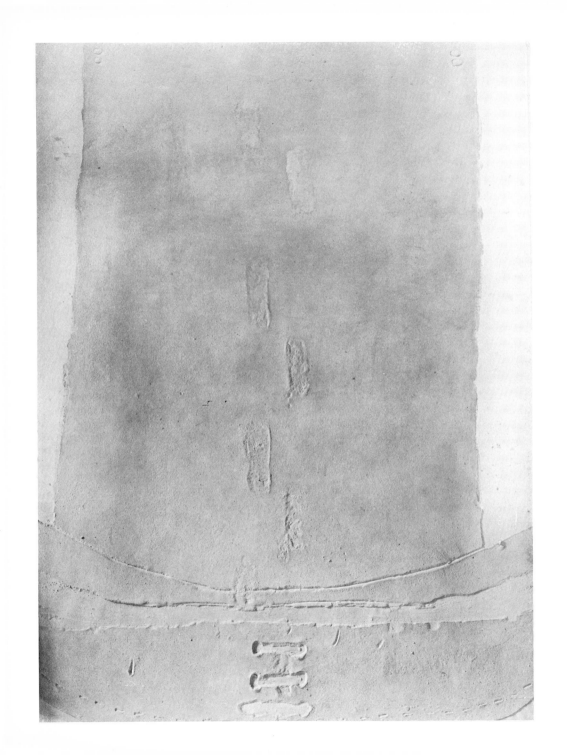

Grey Door, 1958

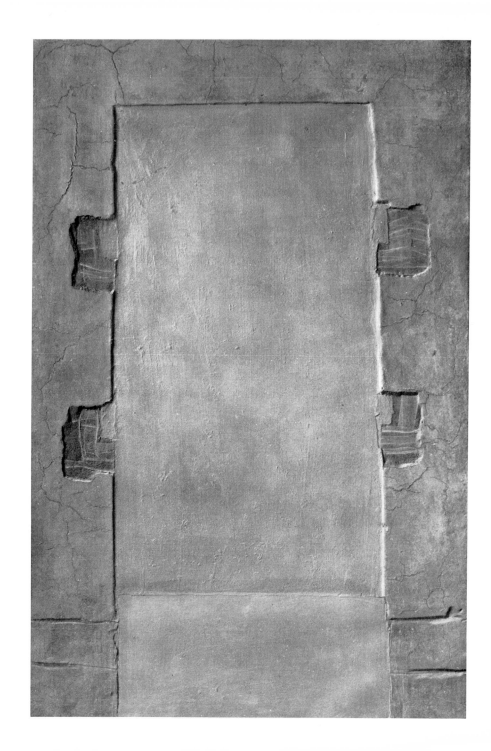

Clear Sand, 1958

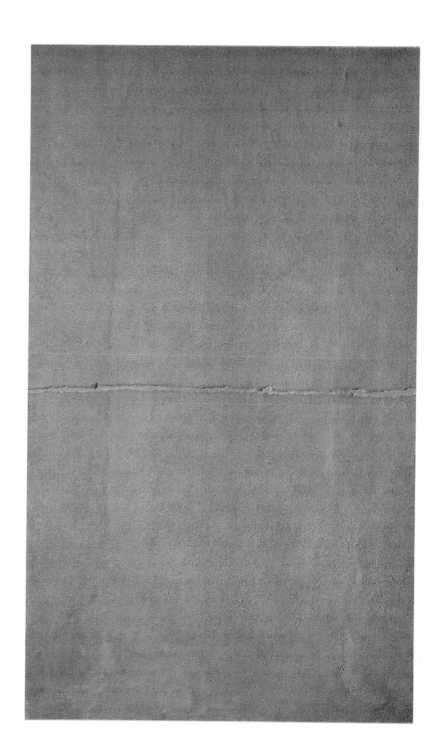

Grey with Two Black Spots, 1959

Large Grey Painting, 1955 ▷

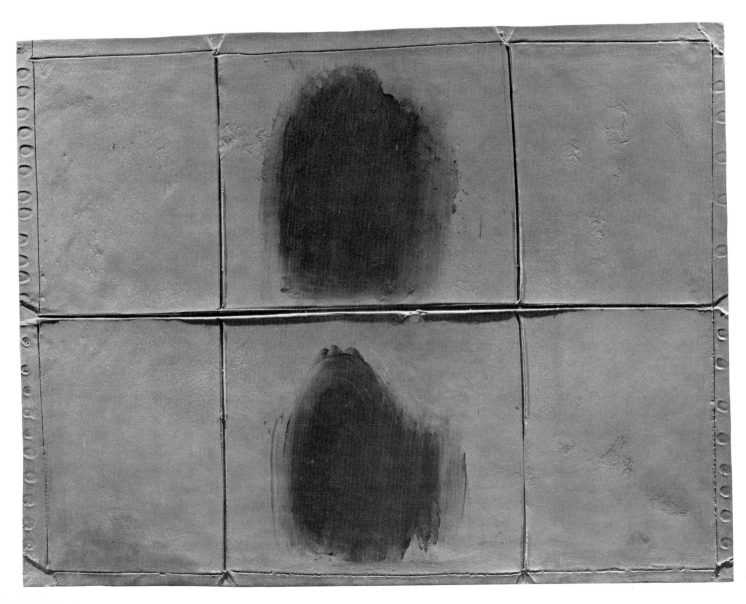

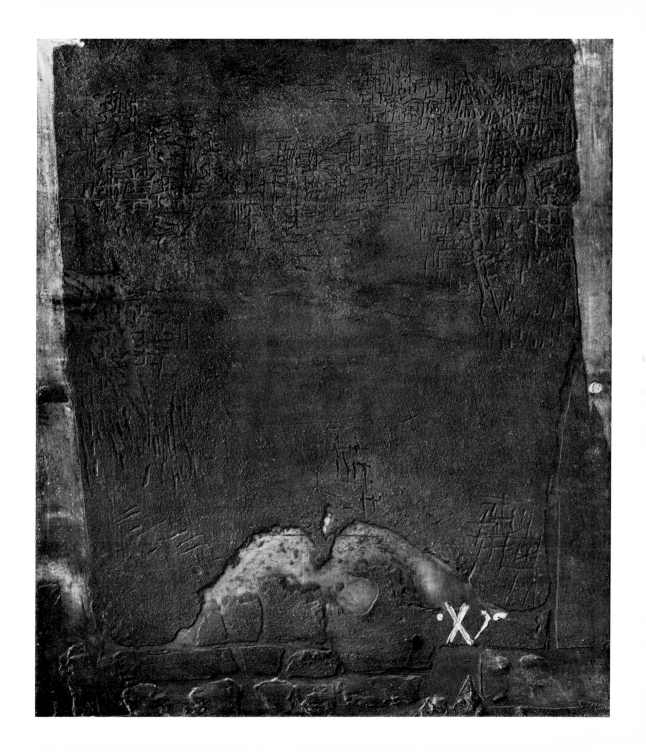

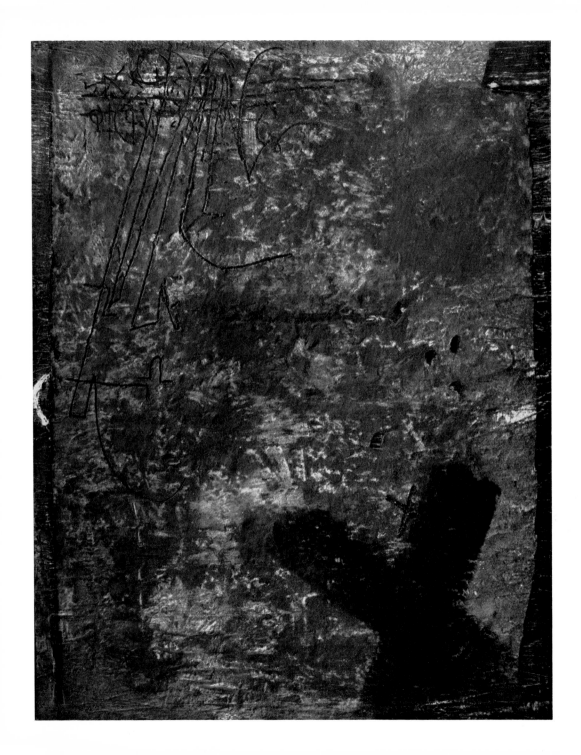

Painting on Wood, verso, 1960

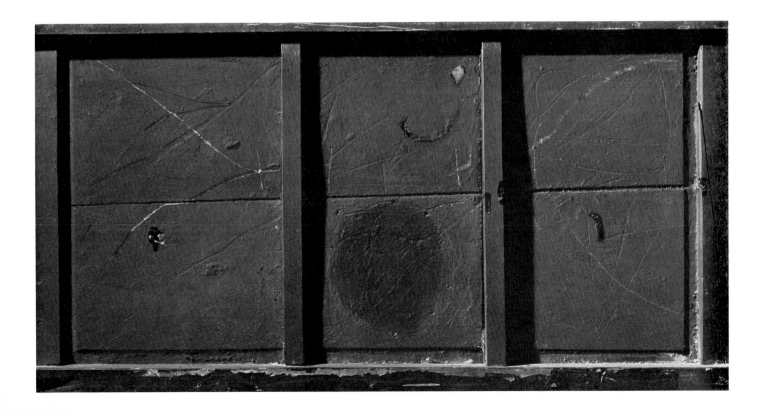

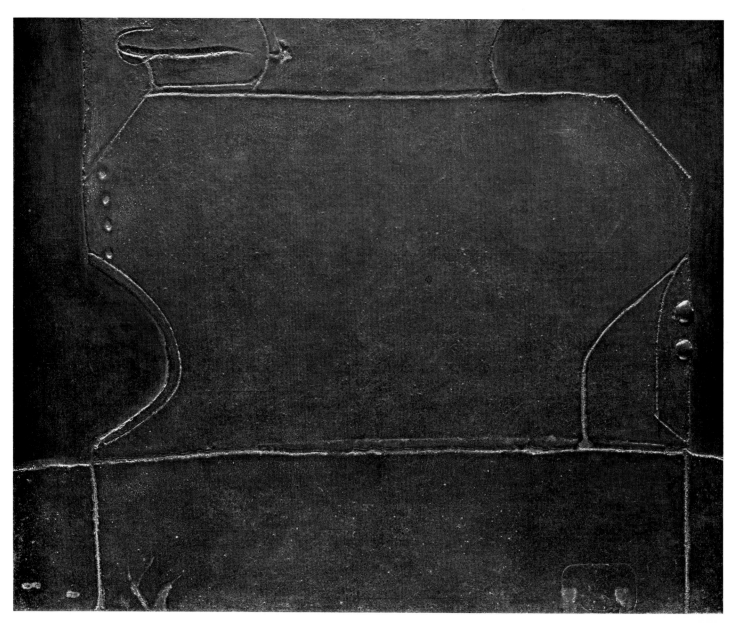

35

Four Boards, 1959–60

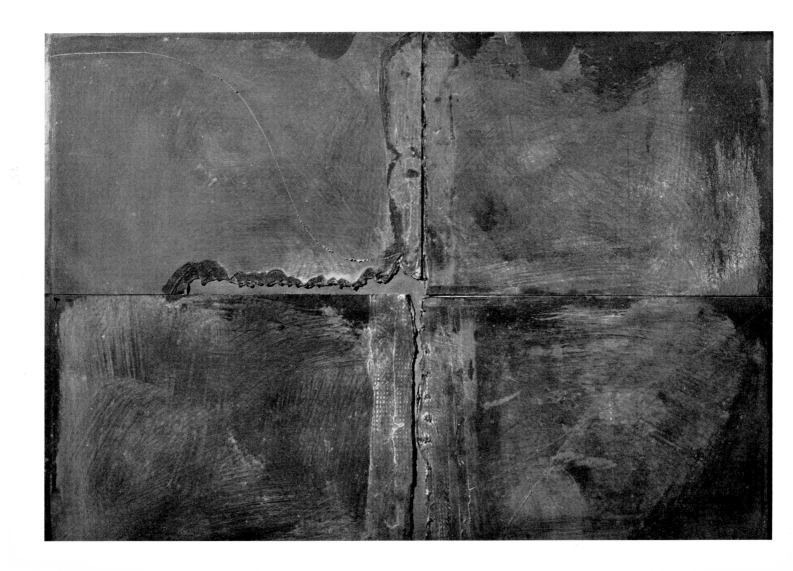

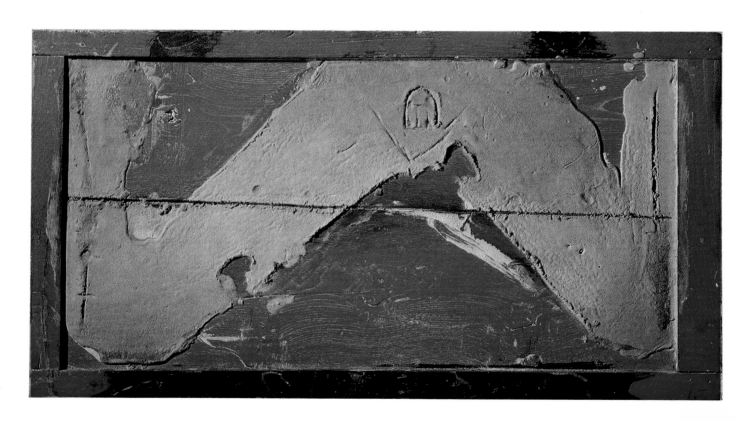

Perpendicular Cords, 1960

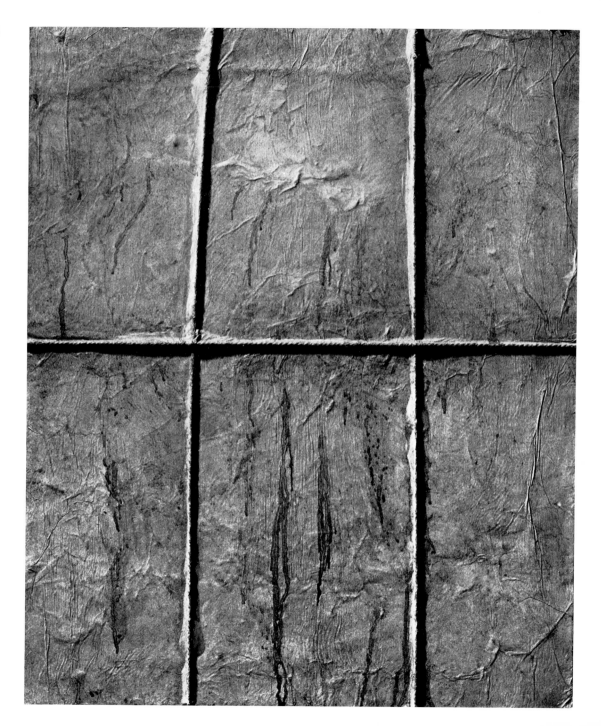

Black on Red, 1962

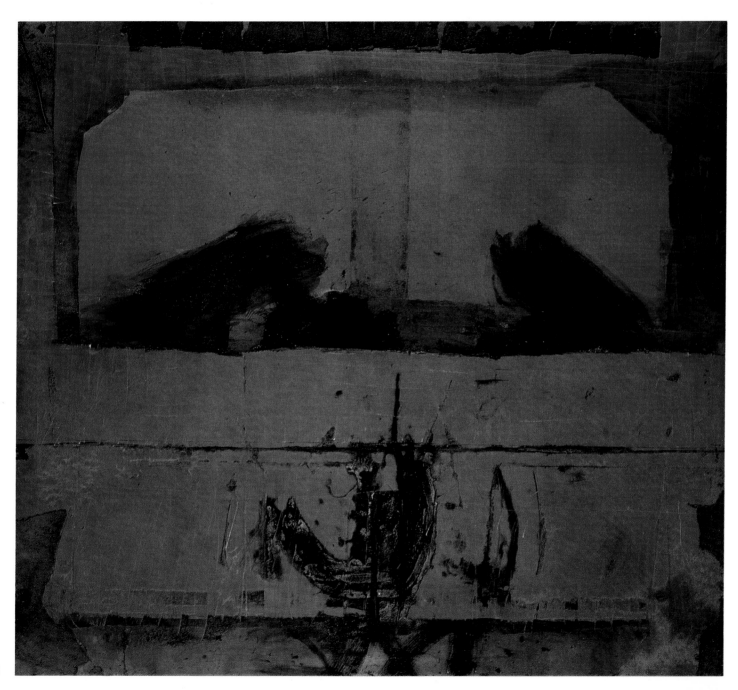

White on Board Ground, 1961

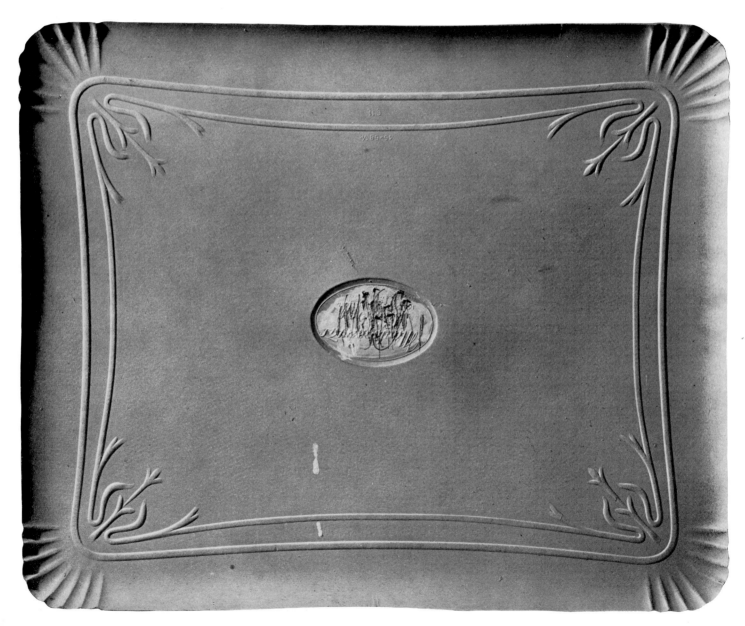

Brown Bed, 1960

Collage of a Plate, 1962

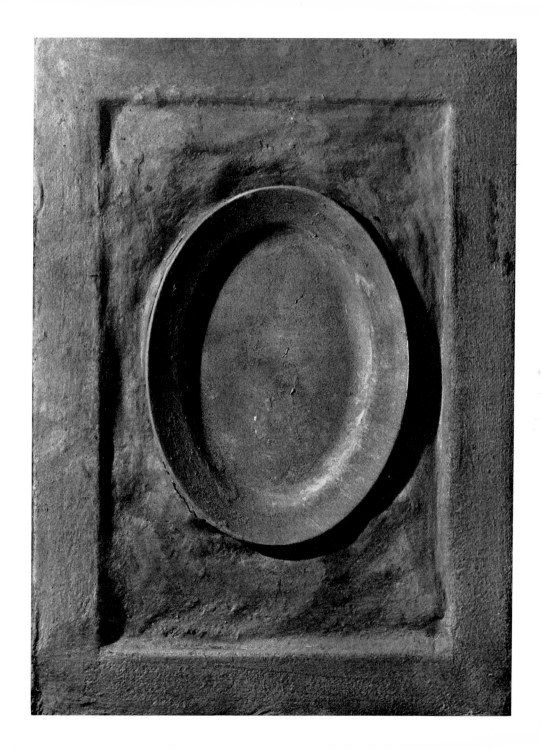

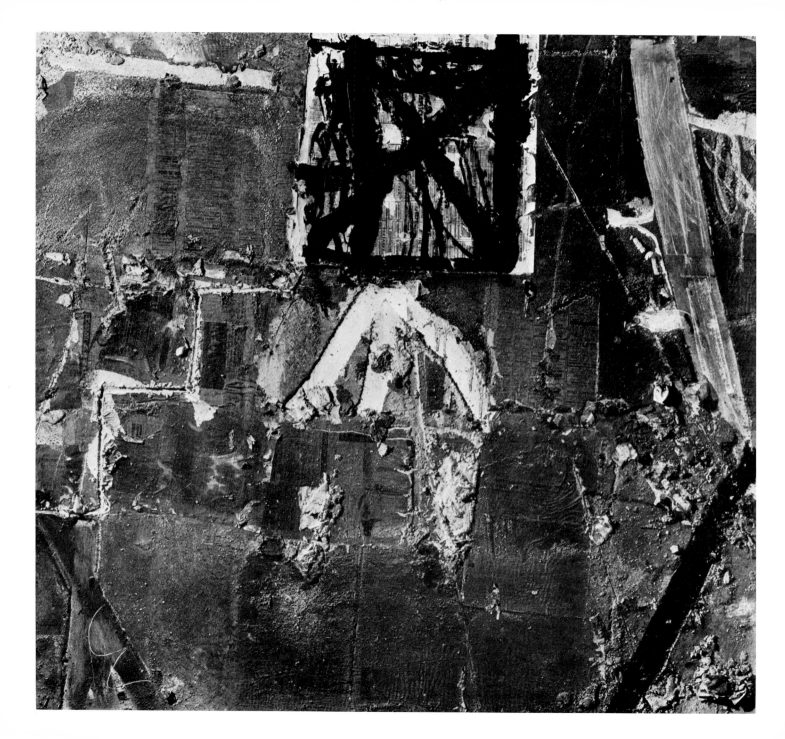

◁ Matière on Canvas and Collage, 1964

◁ Matière on Canvas and Collage, 1964

Composition with Cords, 1963

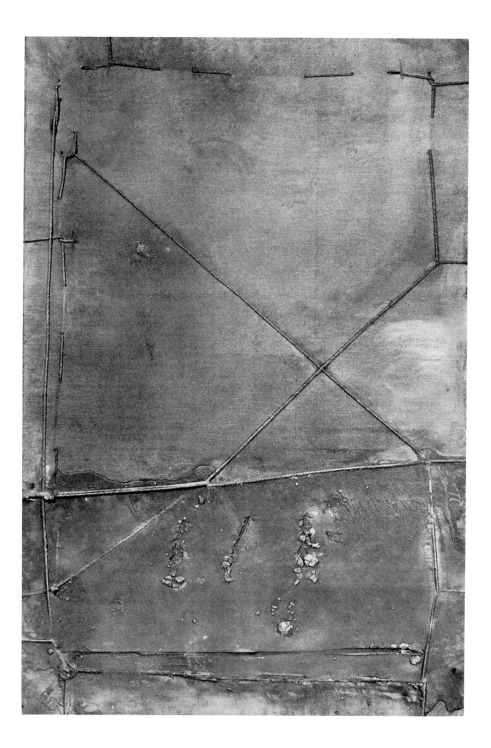

Cloth on Board, 1964

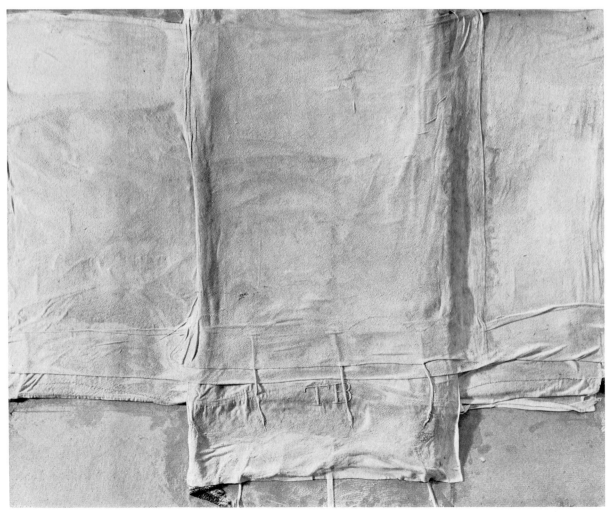

GOSHEN COLLEGE LIBRARY

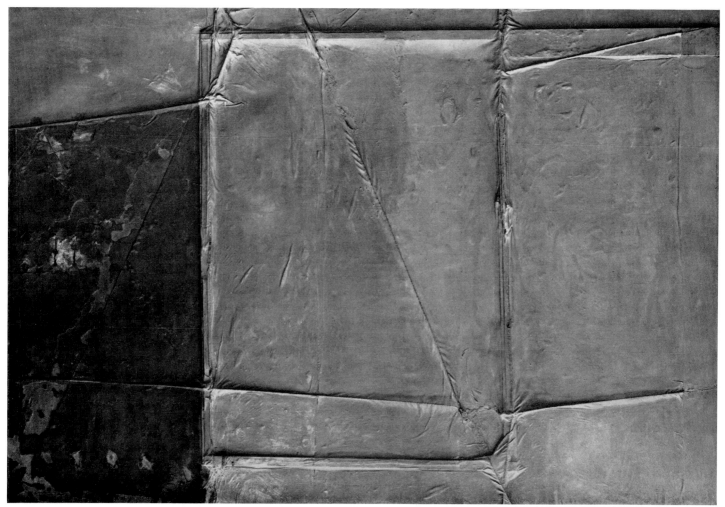

49

GARDNER WEBB COLLEGE LIBRARY

Four Red Bars, 1966

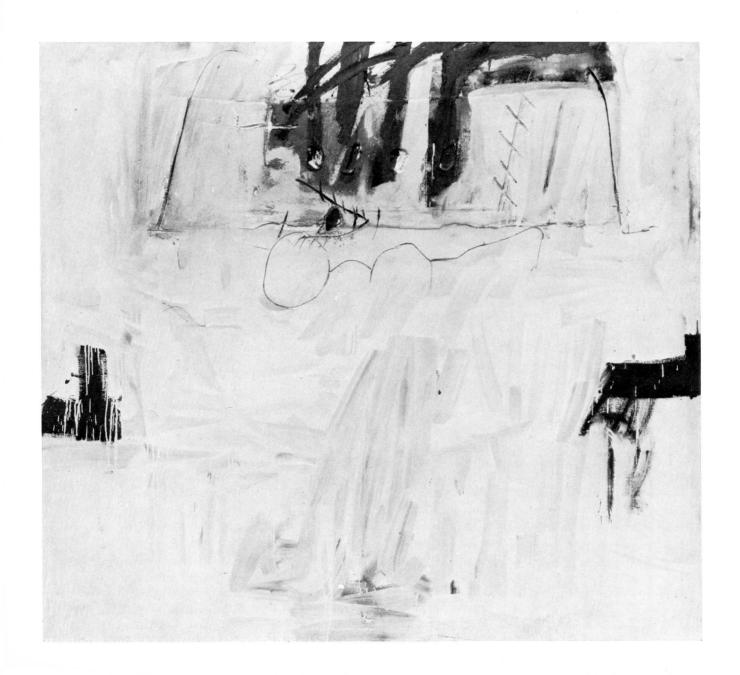

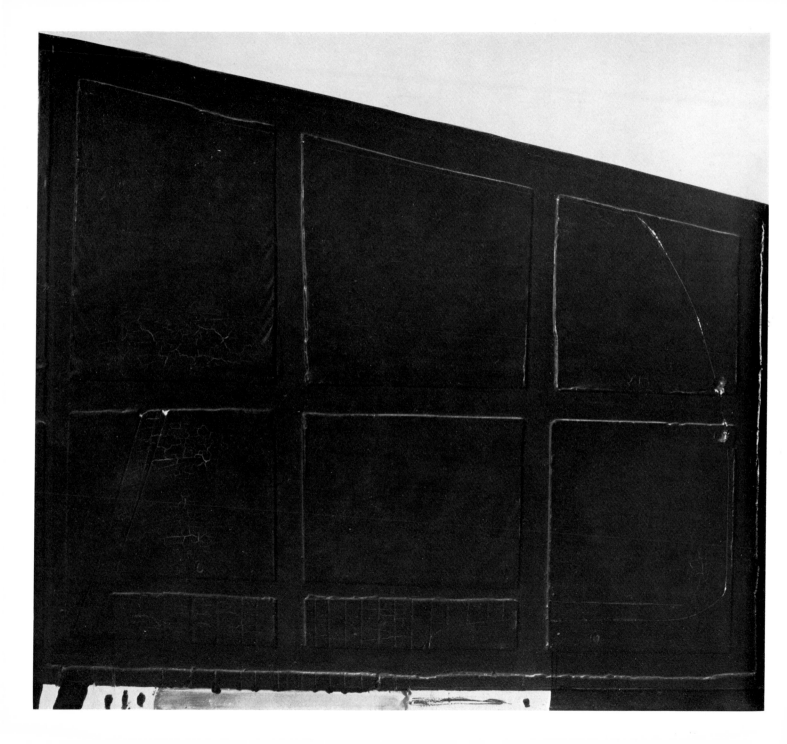

Brown, Ochre and Black, 1965

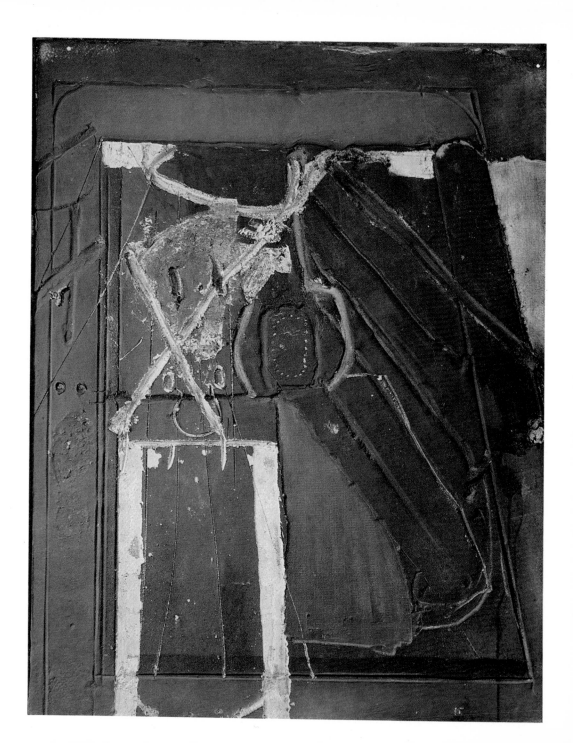

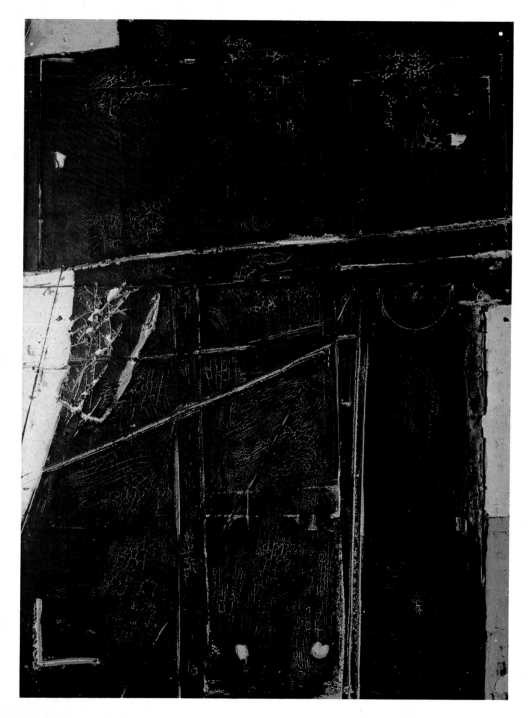

Large Crackled Black and Brown, 1966

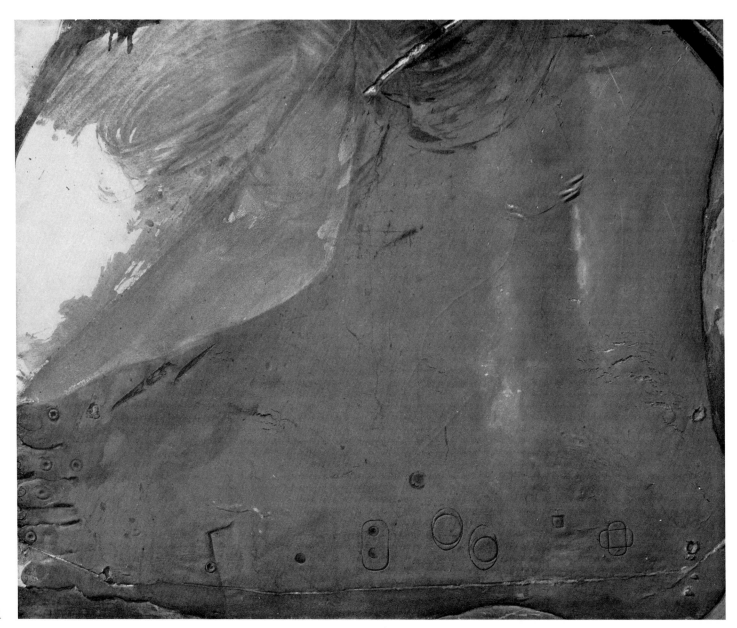

◁ Oblique Cupboard Shape, 1968

Brown Cupboard Shape, 1967

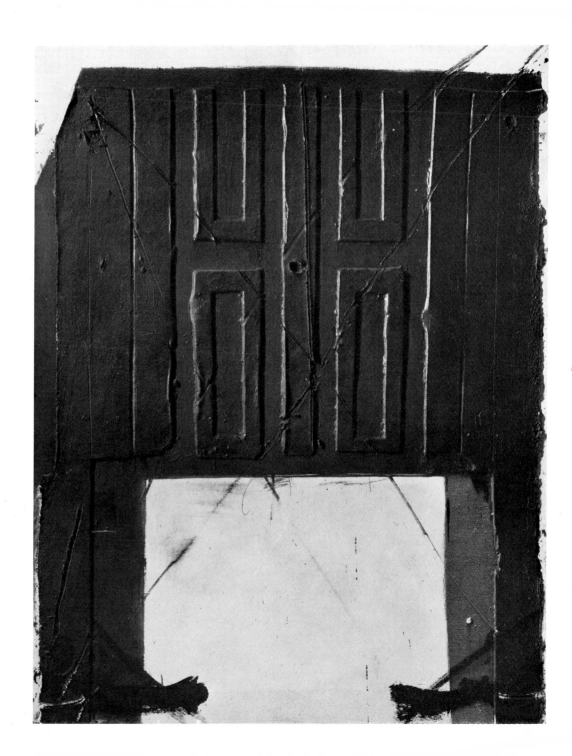

White with Triangle, 1967

Matière Pleated in the Shape of a Nut, 1967 ▷

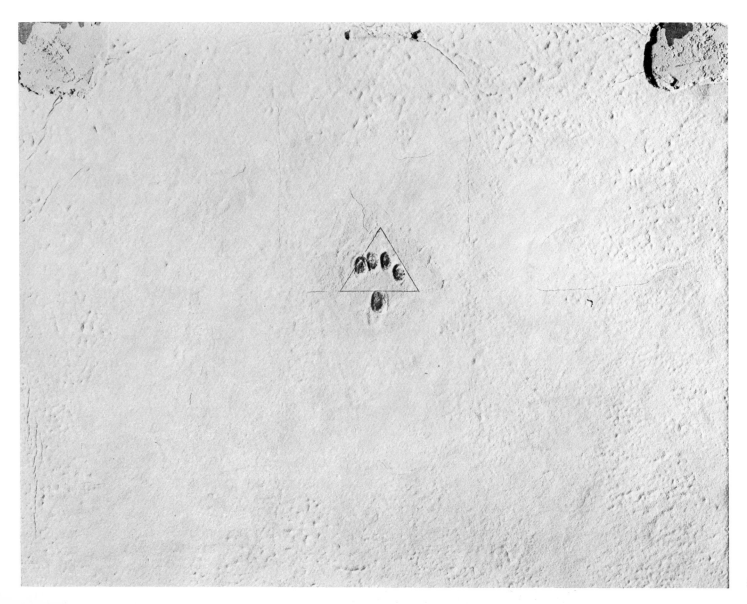

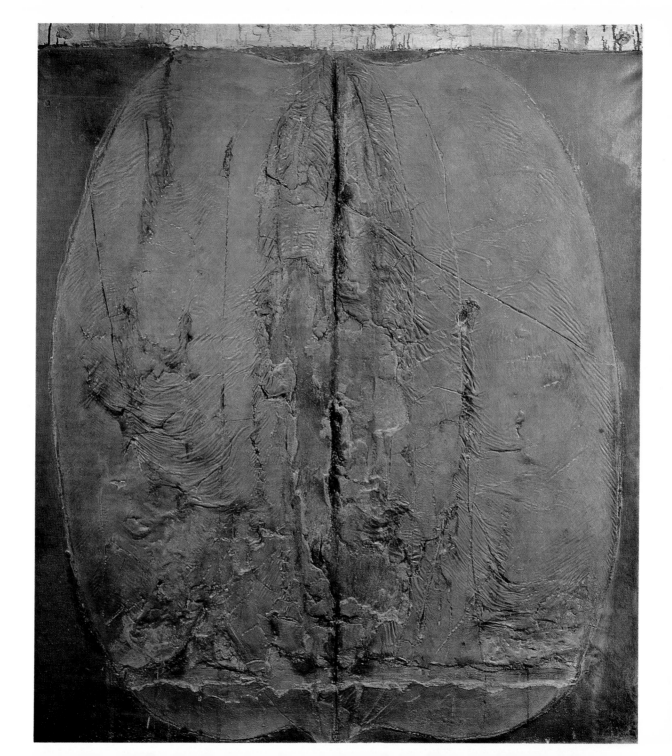

Two Blankets Filled with Straw, 1968

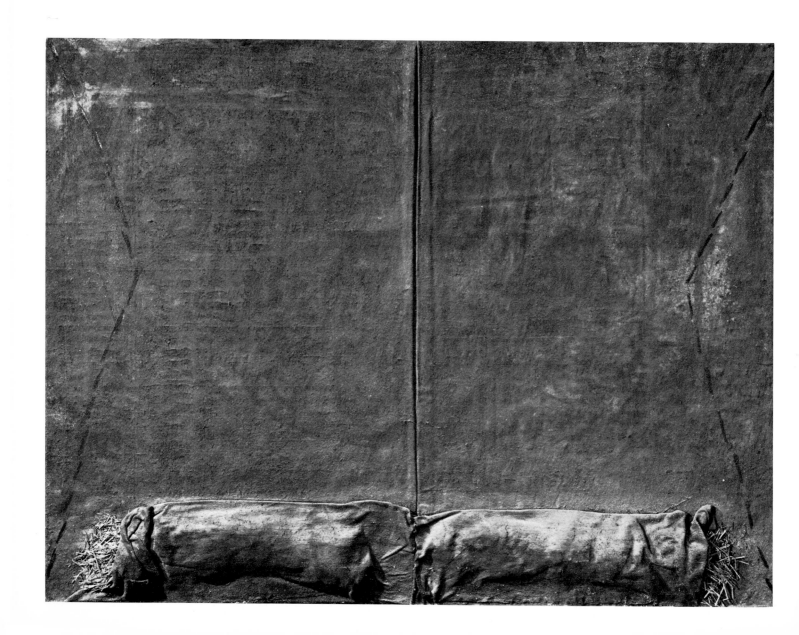

Black Relief on Red Symmetry, 1968

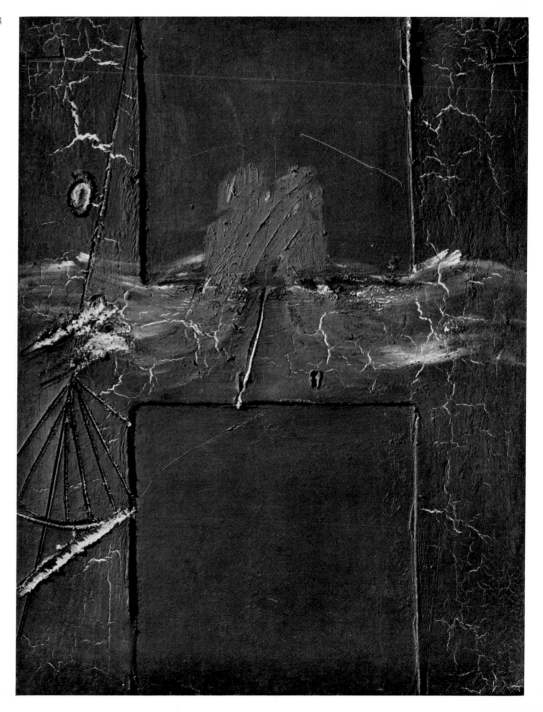

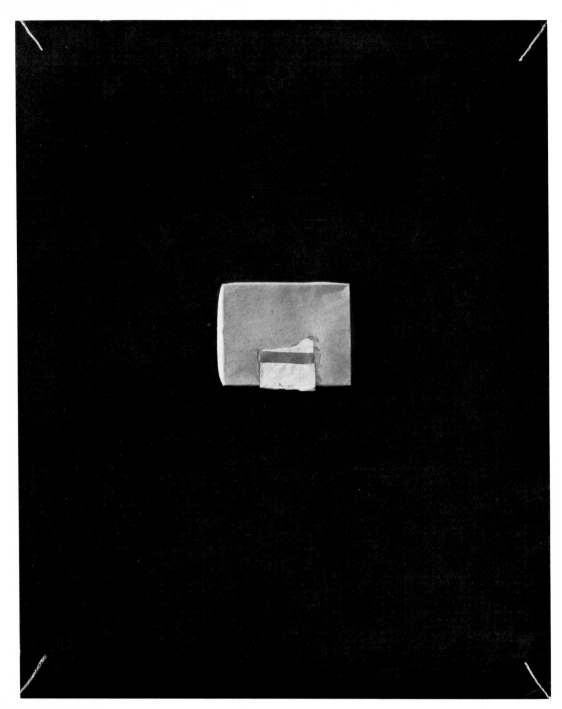

Board Fixed to Dark Canvas, 1969

Circle of Cord, 1969 ▷

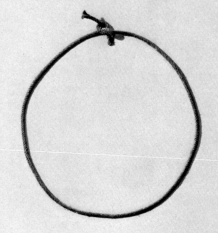

Four Finger and Fist Prints, 1968

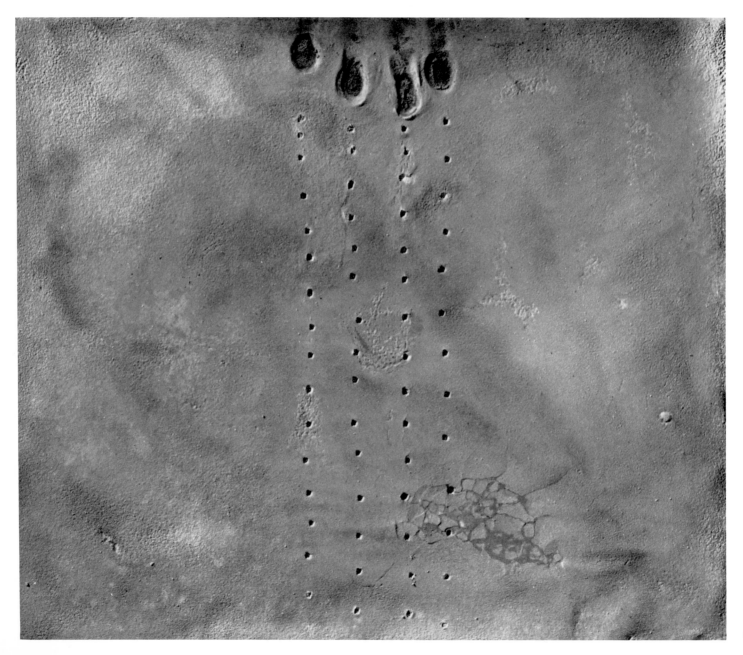

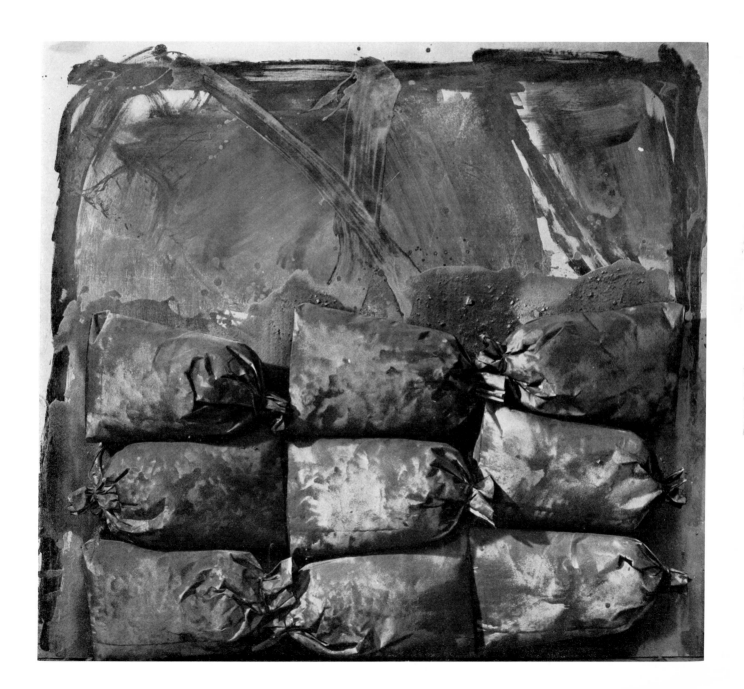

Brown and Plastified Matière, 1969

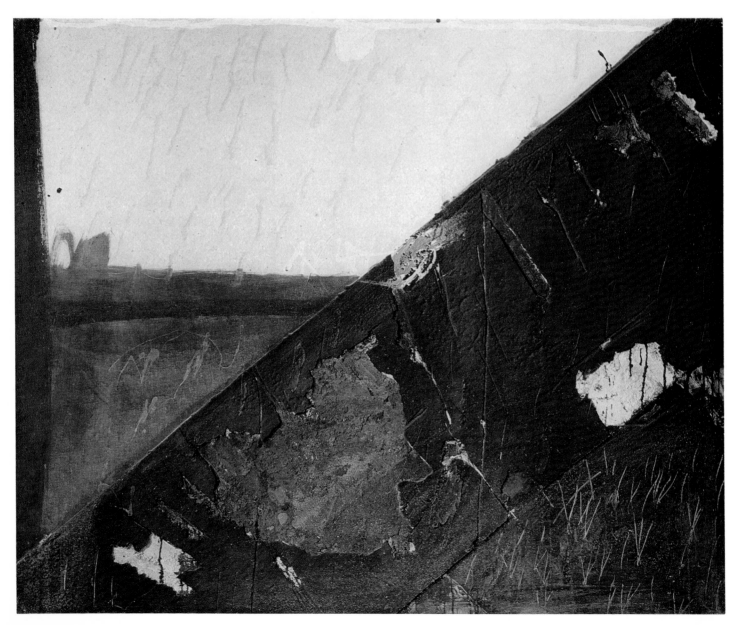

Matière and Glass, 1969

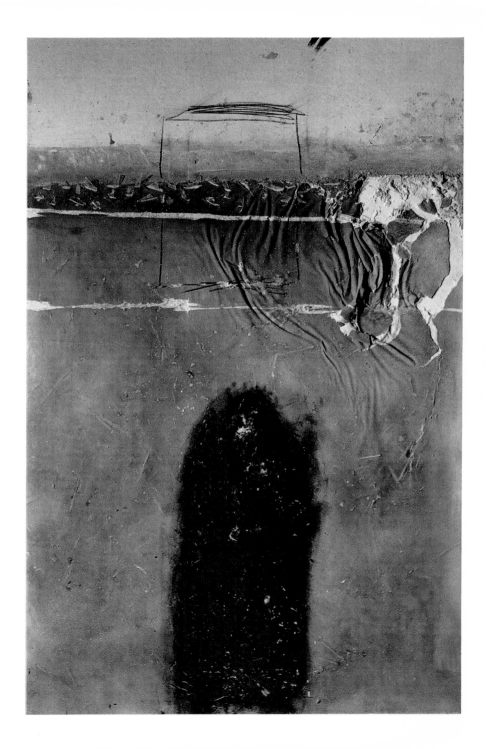

Knotted Sheet, 1969

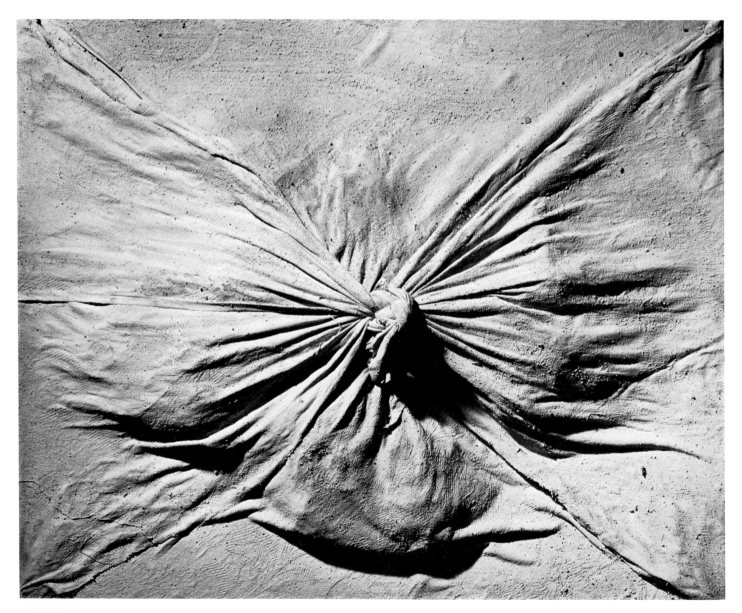

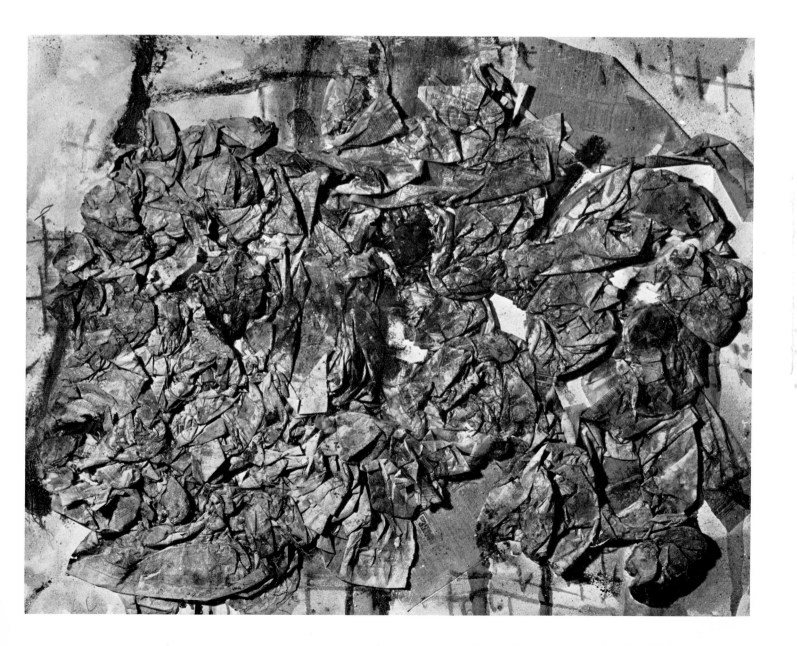

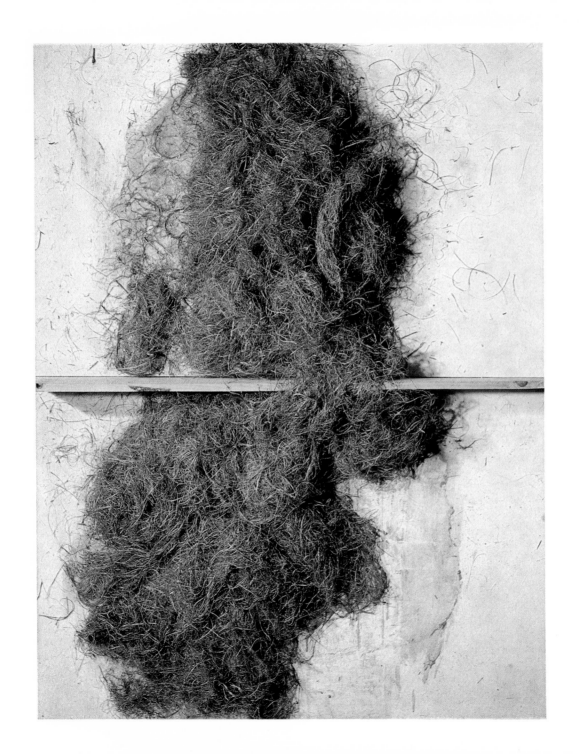

## Notes and References

1 This painting is not reproduced in this book. See the catalogue of the Tàpies exhibition at the Museum des 20.Jahrhunderts, Vienna, 1968, no. 8. The title of the painting, if we are not mistaken, is a Slavonic word meaning Sage. Tàpies probably chose it because of its sonority, and because it remains incomprehensible to a Western reader. Werner Hofmann gives no translation of it in his catalogue, although he provides an exhaustive list of translations of the titles in Catalan, French, English, etc.

2 Tàpies has said in an interview: 'In the same way that Franz Liszt wrote variations on the name of *Bach*, basing them on the notes indicated by the letters, I have used the letters of the alphabet, modifying them slightly, to produce pictorial variations' (Yvon Taillandier, 'Rencontre avec Tàpies en quête de l'homme pur', *XXe siècle*, Paris, no. 24, 1964, pp. 68–76).

3 The standard work on modern Catalan art is Alexandre Cirici-Pellicer, *El arte modernista catalán*, Barcelona, Aymá ed., 1951, from which most of the data quoted here have been drawn. To this must be added the catalogue of the exhibition *El modernismo en España*, Madrid, Casón del Buen Retiro, 1969. A. Cirici-Pellicer, *op. cit.*, p. 45.

4 Y. Taillandier, *op. cit.*, p. 72.

5 See the reproduction in A. Cirici-Pellicer, *op. cit.*, p. 391. In speaking of his 'lunar' paintings, Tàpies evokes A. Altdorfer, Caspar David Friedrich and Max Ernst (Y. Taillandier, *op. cit.*, p. 72). But these same precursors (with the exception, of course, of the last) had already been reflected in Raurich's picture some sixty years before.

6 Cf. A. Cirici-Pellicer, *op. cit.*, p. 43.

7 This extract and all the others are quoted from: Okakura Kakuzo, *The Book of Tea*, Rutland, Vermont, and Tokyo, Charles E. Tuttle Co., fifth edition, 1959. The first edition appeared in 1906.

8 For these two paintings, not illustrated here, see the catalogue of the 1968 exhibition at the Museum des 20.Jahrhunderts, Vienna, nos. 16 and 18.

9 About Chekhov: 'It's extraordinary, he tells you almost nothing. He is almost absent. He gives you bits of reality in its raw state, which cross his mind. No philosophy, nothing solemn: just incidents of intimate life, accidents of daily living. But a whole world of sentiments. We forget that world too much. Even a slight feeling can assume great importance. We think it is necessary to perform high deeds, but the web of daily life can be just as beautiful. What need is there for great deeds?' (Y. Taillandier, *op. cit.*, pp. 71–72).

10 In the catalogue of the 1968 exhibition at the Museum des 20.Jahrhunderts, Vienna, this painting is reproduced under the title *Peinture sur chassis*.

11 Cf. Li Lin-ts'an, 'The Landscape of the Northern and the Southern Sung Dynasties', *The National Palace Museum Bulletin*, Taipeh, Taiwan, vol. 3, no. 3, 1968, pp. 1–11.

12 For the paintings not illustrated here, see the catalogue of the 1968 exhibition at the Museum des 20.Jahrhunderts, Vienna, nos. 29, 36 and 40, and the catalogue of the 1968 exhibition, Kölnischer Kunstverein, no. 35.

13 'I realized that changes of sense and symbol could result from very small alterations. It is then that I began the variations' (Y. Taillandier, *op. cit.*, p. 74).

14 See the catalogue of the 1968 exhibition at the Museum des 20.Jahrhunderts, Vienna, no. 64.

15 Cf. Joan Brossa, 'Oráculo sobre Antoni Tàpies', published in the periodical *Dau al Set* on the occasion of the Tàpies exhibition at the Galerías Layetanas in Barcelona in 1950, and taken up again in Francesco Vicens's monograph *Antoni Tàpies. L'escarnidor de Diadems*, La Polígrafa, Barcelona, 1967. The final quotation is again from *The Book of Tea*.

48 Cloth on Board, 1964
Collage and paint. 73 × 92 cm., 28³/₄ × 36¹/₄″
Sala Gaspar, Barcelona

49 Large Grey Canvas for Kassel, 1964
Mixed media on canvas. 275 × 400 cm., 108 × 157¹/₂″
Galerie Maeght, Paris

50 Four Red Bars, 1966
Paint on canvas. 171 × 195 cm., 67³/₈ × 76³/₄″
Galerie Maeght, Paris

51 Matière Shaped Like a Foot, 1965
Mixed media. 130 × 162 cm., 51¹/₈ × 63³/₄″
Private collection, Barcelona

52 Large Crackled Black and Brown, 1966
Mixed media. 260 × 195 cm., 102³/₈ × 76³/₄″
Sala Gaspar, Barcelona

53 Brown, Ochre and Black, 1965
Mixed media. 162 × 130 cm., 63³/₄ × 51¹/₈″
Collection Gustavo Gili, Barcelona

54 Oblique Cupboard Shape, 1968
Mixed media. 170 × 195 cm., 66⁷/₈ × 76³/₄″
Martha Jackson Gallery, New York

55 Brown Cupboard Shape, 1967
Mixed media. 146 × 114 cm., 57¹/₂ × 44⁷/₈″
Galerie Maeght, Paris

56 White with Triangle, 1967
Mixed media. 81 × 100 cm., 31⁷/₈ × 39³/₈″
Galerie Maeght, Paris

57 Matière Pleated in the Shape of a Nut, 1967
Mixed media. 195 × 170 cm., 76³/₄ × 66⁷/₈″
Galerie Maeght, Paris

58 Two Blankets Filled with Straw, 1968
Mixed media. 198 × 270 cm., 78 × 106¹/₄″
Galerie Maeght, Paris

59 Black Relief on Red Symmetry, 1968
Mixed media. 116 × 89 cm., 45⁵/₈ × 35″. Galerie Maeght, Paris

60 Board Fixed to Dark Canvas, 1969
Mixed media. 162 × 130 cm., 63³/₄ × 51¹/₈″
Martha Jackson Gallery, New York

61 Circle of Cord, 1969
Mixed media. 162 × 162 cm., 63³/₄ × 63³/₄″
Martha Jackson Gallery, New York

62 Four Finger and Fist Prints, 1968
Mixed media. 46 × 55 cm., 18¹/₈ × 21⁵/₈″
Collection Werner Rusche, Cologne

63 Collage with Sacks, 1969
Mixed media. 183 × 165 cm., 72 × 65″
Galerie Maeght, Paris

64 Brown and Plastified Matière, 1969
Mixed media. 130 × 162 cm., 51¹/₈ × 63³/₄″
Martha Jackson Gallery, New York

65 Matière and Glass, 1969
Mixed media. 196 × 130 cm., 77¹/₈ × 51¹/₈″
Sala Gaspar, Barcelona

66 Knotted Sheet, 1969
Mixed media. 81 × 100 cm., 31⁷/₈ × 39³/₈″
Galerie Maeght, Paris

67 Gathered Newspapers, 1969
Mixed media. 89 × 116 cm., 35 × 45⁵/₈″
Galerie Maeght, Paris

68 Straw and Wood, 1969
Collage. 150 × 116 cm., 59 × 45⁵/₈″
Private collection, Barcelona

## Biographical Notes

1923   Tàpies born in Barcelona on 13 December. His father, a lawyer, belonged to a family of professors, architects and jurists, his mother to an old family of booksellers. The liberal and cultured family atmosphere fostered his interest in literature and music, the initial impetus of which was aroused by his father's books and record collection.

1926   Pupil at the college of the Sisters of Loreto in Barcelona.

1928   Elementary studies at the German School of Barcelona.

1931   Continued his studies at the Balmes College of the Order of Christian Schools.

1934   Beginning of secondary studies. First drawings and paintings. Interested in the ancient art of Sumer and Egypt and gave a lecture at school on the subject of cuneiform script. First contacts with contemporary art, notably through a special issue of the magazine directed by Joan Prats and José Luis Sert, *D'Aci i D'Alla*.

1936   Civil war, bombardment of Barcelona. Tàpies studied at the Liceo Prático and continued his study of painting, self-taught.

1938   Discovered the philosophy and art of the East.

1939   Student at the Menéndez y Pelayo Institute.

1940   Again at the Balmes Institute. An accident brought about a heart attack; shortly afterwards he fell severely ill and had to spend two years convalescing in the mountains. Deep spiritual crisis. Continued his reading and improved his knowledge of romantic and contemporary music. Paintings and drawings of expressionist inspiration.

1942   Did copies of Van Gogh and Picasso. Read Nietzsche, Dostoyevsky, Poe, Ibsen, Unamuno, etc.

1943   Entered the Faculty of Law of Barcelona University where he was to study until 1946. At the same time he set up a studio.

1944   Attended the Nolasc Valls Academy of Drawing for two months.

1945   Produced a considerable number of works in the 'antiaesthetic' spirit of Dada. Used *hautes-pâtes*, collages, untreated materials, graffiti.

1946   Became interested in Existentialism.

1947   Made the acquaintance of the poet and playwright Joan Brossa and the collector Joan Prats, an intimate friend of Miró.

1948   With a group of writers and artists took part in the founding of the periodical *Dau al Set*, directed by Joan Brossa. Exhibited for the first time at the Barcelona Salón de Octubre, showing two 1947 paintings: *Painting* and *Collage of Crosses*. Made the acquaintance of Joan Miró.

1949   First etchings, engraved in Enrico Tormo's studio. Works of Surrealist inspiration (Miró, Klee, Ernst, Tanguy, Magritte). Continued his studies of Oriental art and philosophy.

1950   Studied Marxist thought.
Obtained from the French Government a scholarship for a stay in Paris.

1951   Visit to Belgium and Holland. Called on Picasso. Dissolution of the group *Dau al Set*.

1952   Included in Enrique Lafuente Ferrari's selection for the Venice Biennale. Works of geometrical and abstract tendencies.

1953   First retrospective exhibition in the United States. Exhibited at the Martha Jackson Gallery in New York and signed a contract. Returned to the techniques of his first works, *hautes-pâtes*, collages, graffiti; discovered the mineral quality of *matière*, using powdered marble. Engaged in the systematic exploration of matter: *égratignures*, perforations, modelling.

1954   Martha Jackson organized numerous exhibitions in the United States. First prize at the Barcelona Salón del Jazz.
Met Michel Tapié in Paris, who became interested in his work and included it in his conception of '*un art autre*'.
Married Teresa Barba Fábregas.

1955   Through Michel Tapié, met Rodolphe Stadler. Took part in the inaugural exhibition of the Galerie Stadler, Paris.
Republic of Colombia Prize at the Bienal Hispano-Americana in Barcelona.

1957   Award of a Lissone prize in Milan.

1958   Personal room at the Venice Biennale brought him a Unesco prize and the David Bright Foundation prize.
First lithographs.
Painting prize at the Carnegie Institute exhibition, Pittsburgh.

1959   Second visit to the United States.
Three paintings commissioned by the Municipality of Barcelona to decorate one of its halls.

1960   Won prize at the 'International Exhibition of Graphic Art', Tokyo.
The periodical *Papeles de Son Armadans*, directed by Camilo José Cela, devoted a special issue to him.

1961   Another journey to the United States.

1962   Visit to England and Germany.
Designed sets for the play *Or i Sal* by Joan Brossa.
Executed a large mural in the library of the Handelshochschule, St Gallen.

1963  Prize awarded by the Art Club of Providence, Rhode Island.
Publication of *El pa a la barca*, poems by Joan Brossa and litho-collages by Tàpies.
Visit to Rome and Southern Italy.
Produced three large paintings for his own room at 'Documenta III', Kassel.

1965  Went to Switzerland to carry out the 'Album St Gallen'. Visited London.
Executed a tapestry for the first Tapestry Biennale, Lausanne.
A book, in collaboration with Joan Brossa: *Novel-la* published by the Sala Gaspar, Barcelona.
Stained glass for the monastery of the Capuchin fathers in Barcelona and for Sion in Switzerland.

1966  Grand Prix du Président de la République at the Menton Biennale.
Awarded gold medal at the fifteenth International Congress of Critics, Artists and Art Historians at Rimini.
Publication of the portfolio *Nou variacions sobre tres gravats de 1947–48* (Sala Gaspar, Barcelona).

1967  Invited to Cuba on the occasion of the Salón de Mayo. Though he was unable to go, his work was nonetheless exhibited.
Grand Prix of the 7th International Biennale of Graphic Arts. Ljubljana. Lithographs for the book *La nuit grandissante* by Jacques Dupin (Erker, St Gallen).

1970  With Miró took part in the meeting of Spanish intellectuals at Montserrat Abbey during the legal proceedings against the Basque Nationalists.
Executed a mural for the Municipal Theatre of St Gallen.

# Exhibitions

## One-man Exhibitions

1950  Barcelona, Galerías Layetanas.
Mataró (Barcelona), Museo de la Casa de Cultura.

1952  Barcelona, Galerías Layetanas.

1953  Chicago, Marshall Field Art Gallery.
Madrid, Galería Biosca.
New York, Martha Jackson Gallery.

1954  Barcelona, Galerías Layetanas.

1955  Barcelona, Club 49, Sótanos de la Sala Gaspar.
Stockholm, Sturegalleriet (with Tharrats and Isern).

1956  Paris, Galerie Stadler.
Barcelona, Club 49, Sala Gaspar.

1957  Paris, Galerie Stadler.
Düsseldorf, Galerie Schmela.
New York, Martha Jackson Gallery.

1958  Milan, Galleria dell'Ariete.
Venice, special room in the Spanish pavilion at the 29th Biennale.

1959  New York, Martha Jackson Gallery.
Washington, Gress Gallery.
Paris, Galerie Stadler.
Munich, Galerie Van de Loo (with Antonio Saura).

1960  Barcelona, Sala Gaspar.
Bilbao, Museum del Arte.
New York, Martha Jackson Gallery. Lithographs.
Milan, Galleria dell'Ariete. Lithographs (with Jean Dubuffet).

1961  New York, Martha Jackson Gallery. Works of 1959–60.
Washington, Gress Gallery.
Paris, Galerie Stadler.
Buenos Aires, Museo Nacional, Instituto Torcuato Di Tella.
Stockholm, Galerie Blanche.
Munich, Galerie Otto Stangl (with Sam Francis).
Essen, Galerie Rudolf Zwirner.
New York, David Anderson Gallery. Lithographs.

1962  Hanover, Kestner-Gesellschaft. Works of 1945–62.
Zurich, Kunsthaus. Works of 1945–62.
New York, The Solomon R. Guggenheim Museum. Retrospective of the works of 1945–62.

Caracas, Museo Nacional de Bellas Artes.
Rome, Galleria Il Segno. Lithographs.
Stockholm, Galerie Pierre. Lithographs.

1963  Pasadena, Pasadena Art Museum.
Paris, Galerie Berggruen. Works on paper and cardboard.
St Gallen, Galerie Im Erker.
Turin, International Centre of Aesthetic Research. Lithographs.
Turin, Galleria Notizie.
New York, Martha Jackson Gallery.

1964  Madrid, Cacharrería del Ateneo.
Rome, Galleria La Tartaruga.
Cologne, Galerie Rudolf Zwirner. Works on cardboard and collages.
Paris, Galerie Stadler.
Stockholm, Galleriet Burén.
Toronto, Gallery Moos.
Montreal, Galerie Agnès Lefort.
Barcelona, Sala Gaspar. Works on paper, cardboard, wood and collages of 1946–64.

1965  Solothurn, Galerie Bernard. Paintings and lithographs.
Munich, Galerie Van de Loo.
Cologne, Galerie Rudolf Zwirner. Paintings of 1948–64.
London, Institute of Contemporary Arts.
St Gallen, Galerie Im Erker. Lithographs (Album St Gallen).
Barcelona, Sala Gaspar. Gouaches and drawings for Joan Brossa's *Novel-la*.

1966  Manresa (Barcelona), Círculo Artístico. Lithographs.
Madrid, Galería Biosca.
Paris, Galerie Stadler.
Toulouse, Centre Culturel (with Clavé and Pelayo).
Cannes, Galerie Jacques Verrière.
Stockholm, Galleriet Burén. Gouaches and collages.

1967  New York, Martha Jackson Gallery.
Paris, Galerie Maeght. Retrospective exhibition.

1968  Vienna, Museum des 20. Jahrhunderts. Works of 1945–68.
Hamburg, Kunstverein. Works of 1945–68.
Cologne, Kölnischer Kunstverein. Works of 1945–68.
New York, Martha Jackson Gallery.
Paris, Galerie Maeght. Collages and *papiers déchirés*.

1969  Paris, Galerie Stadler.
Lausanne, Galerie A. et G. May. Lithographs.
Paris, Galerie Maeght.
Bonn, Galerie Wünsche.
Barcelona, Sala Gaspar. Paintings, tapestries, graphic work and 'Fregoli'.

Toronto, Gallery Moos. Paintings, collages, works on paper.

1970  Milan, Galleria dell'Ariete.
New York, Martha Jackson Gallery.
Barcelona, Sala Gaspar. Presentation of 'Nocturn Matinal'.

1971  Zurich, Galerie Maeght. Works on paper and objects.
Rome, Il Collezionista d'Arte Contemporaneo.
Bologna, Galleria San Luca.
Palma de Mallorca, Galeria Pelaires.
Hagen, Karl-Ernst-Osthaus Museum.
Cologne, Galerie Dreiseitel. A carpet and graphic works.
Malmö, Galerie Börjeson. Gouaches and graphics.
London, Galerie Hachette. Prints.

## Collective Exhibitions

1948  Salón de Octubre, Barcelona.

1949  'Un Aspecto de la Pintura Catalana', Institut Français de Barcelona.
Salón de Octubre, Barcelona.
Salón de los Once, Madrid.
Galeria Sapi, Palma de Mallorca.

1950  Institut Français de Barcelona.
'Las Once Mejores Obras de Arte del Año', Academia Breve, Madrid.
Salón de los Once, Madrid.
The Pittsburgh International Exhibition of Contemporary Painting, Carnegie Institute, Department of Fine Arts, Pittsburgh.

1951  'L'Exposició Dau al Set', Sala Caralt, Barcelona (with J. Brossa, J. E. Cirlot, M. Cuixart, J. Pons, A. Puig, J. J. Tharrats).
Salón de Octubre, Barcelona.
I Bienal Hispano-Americana de Arte, Madrid.
Salón de los Once, Madrid.

1952  XXVI Mostra Biennale Internazionale d'Arte, Venice.
Salón de los Once, Madrid.
Galeria Sur, Santander.
The Pittsburgh International Exhibition of Contemporary Painting, Carnegie Institute, Department of Fine Arts, Pittsburgh.

1953  Exposición municipal de Bellas Artes, Barcelona.
Museo Nacional, Bogotá.
Universidad de Panamá, Panama City.
II Bienal do Museu de Arte Moderna, São Paulo.
II Bienal Hispano-Americana de Arte, Havana.

'Pintores Españoles', Santiago de Chile.

'La Pintura Catalana Actual', Barcelona.

'Las Once Mejores Obras de Arte del Año', Academia Breve, Madrid.

Salón de los Once, Madrid.

1954 XXVII Mostra Biennale Internazionale d'Arte, Venice.

Salón del Jazz, Barcelona.

Wadsworth Atheneum, Hartford, Conn.

Nebraska Art Association, 64th Annual Exhibition, Lincoln.

Milwaukee Art Institute, Milwaukee.

'Reality and Fantasy 1900–1954', Walker Art Center, Minneapolis.

1955 'Phases de l'Art Contemporain', Galerie Creuse, Paris.

Galerie du Dragon, Paris.

Galerie Stadler, Paris.

III Bienal Hispano-Americana de Arte, Barcelona.

The Pittsburgh International Exhibition of Contemporary Painting, Carnegie Institute, Department of Fine Arts, Pittsburgh.

1956 'Expressions et Structures', Galerie Stadler, Paris.

The Arts Council of Great Britain, London.

Whitworth Art Gallery, Manchester.

XXVIII Mostra Biennale Internazionale d'Arte, Venice.

1957 IV Bienal do Museu de Arte Moderna, São Paulo.

'50 Ans d'Art Abstrait', Galerie Creuse, Paris.

Galerie Stadler, Paris.

Salon de Mai, Paris.

'The Exploration of Form', Arthur Tooth & Sons, London.

Premio Lissone, Milan.

Rome–New York Art Foundation, Rome.

'Arte Otro', Barcelona and Madrid.

Martha Jackson Gallery, New York.

1958 'Some Paintings from the E.J. Power Collection', The Institute of Contemporary Arts, London.

Salon de Mai, Paris.

Galerie Stadler, Paris.

'The Exploration of Form', Arthur Tooth & Sons, London.

XXIX Mostra Biennale Internazionale d'Arte, Venice.

Osaka Festival, Osaka.

Martha Jackson Gallery, New York.

The Pittsburgh International Exhibition of Contemporary Painting, Carnegie Institute, Department of Fine Arts, Pittsburgh.

'L'Art du XXe siècle', Palais des Expositions, Charleroi.

'Neue Malerei in Frankreich', Städtische Kunstsammlungen, Soest.

1959 'Documenta II', Kassel.

Premio Lissone, Milan.

' "Arte Nuova", Esposizione Internazionale di Pittura e Scultura, Circolo degli Artisti', Palazzo Graneri, Turin.

International Center of Aesthetic Research, Festival di Torino, Turin.

'Antoni Tàpies et Alberto Burri', Galerie Beyeler, Basel.

'4 Maler', Kunsthalle, Bern (with Alechinski, Messagier and Moser).

Salon de Mai, Paris.

'European Art Today', Minneapolis Institute of Arts, Minneapolis and Los Angeles County Museum (also shown in 1960 at The Baltimore Museum of Art; San Francisco Museum of Art; National Gallery of Canada, Ottawa; French & Co., New York).

'Recent Acquisitions', The Museum of Modern Art, New York.

North Carolina Museum of Art, Raleigh.

'15 Maler in Paris', Kölnischer Kunstverein, Cologne.

Inaugural exhibition, The Solomon R. Guggenheim Museum, New York.

1960 'Antagonismes', Musée des Arts Décoratifs, Paris.

Städtisches Museum, Leverkusen.

'Four Internationals', Gallery Moos, Toronto.

'La Nueva Pintura de España', Arthur Tooth & Sons, London.

Galerie Stadler, Paris.

'The Pursuit and Measure of Excellence', Weatherspoon Art Gallery, University of North Carolina, Greensboro.

'The New Spanish Painting and Sculpture', The Museum of Modern Art, New York.

'Before Picasso—after Miró', The Solomon R. Guggenheim Museum, New York.

Martha Jackson Gallery, New York.

'Neue Malerei', Städtische Galerie, Munich.

'Jonge Kunst uit de Collectie Dotremont', Stedelijk van Abbe Museum, Eindhoven.

Salon de Mai, Paris.

'New Forms—New Media', Martha Jackson Gallery, New York.

'Picasso, Miró, Tàpies, Saura, Chillida', Ingelheim, Germany.

International Exhibition of Graphic Art, Tokyo.

1961 'New Europeans', Contemporary Arts Museum, Houston.

'Recent Acquisitions', The Museum of Modern Art, New York.

The Pittsburgh International Exhibition of Contemporary Painting and Sculpture, Carnegie Institute, Department of Fine Arts, Pittsburgh.

'Arte e Contemplazione', Palazzo Grassi, Venice.

Salon de Mai, Paris.

'One Hundred Paintings from the G. David Thompson Collection', The Solomon R. Guggenheim Museum, New York.

'Kompas', Stedelijk van Abbe Museum, Eindhoven.

1962 'Exposición de pintura catalana. Desde prehistoria hasta nuestros días', Casón del Buen Retiro, Madrid.

'Modern Spanish Painting', The Arts Council of Great Britain, Tate Gallery, London.

'Contemporary Spanish Painting and Sculpture', Marlborough Fine Art Ltd., London.

Salon de Mai, Paris.

The 30th Exhibition of the Japan Print Association, Tokyo.

'L'Incontro di Torino', Palazzo della Promotrice al Valentino, Turin.

1963 Salon de Mai, Paris.

First Salon of the Galeries Pilotes, Lausanne.

The Dunn International, The Beaverbrook Art Gallery, Fredericton, New Brunswick, and Tate Gallery, London.

'Profile I.—Strukturen und Stile', Städtische Kunsthalle, Bochum.

1964 'Guggenheim International Award', The Solomon R. Guggenheim Museum, New York.

'Documenta III', Kassel.

'Painting and Sculpture of a Decade', Calouste Gulbenkian Foundation, Lisbon, and Tate Gallery, London.

Salon de Mai, Paris.

The Pittsburgh International Exhibition of Contemporary Painting and Sculpture, Carnegie Institute, Department of Fine Arts, Pittsburgh.

'España Libre', Rimini, Florence, Reggio Emilia, Venice, Ferrara.

1965 Salon de Mai, Paris.

'4 International' (Burri, Nevelson, Tàpies, Van Leyden), Martha Jackson Gallery, New York.

'40 Key Artists of the Mid-20th Century', Institute of Art, Detroit.

International 65, The J.L. Hudson Gallery, Detroit.

'Les oeuvres intégrées dans l'architecture', Galerie Alice Pauli, Lausanne.

'Weiss-Weiss', Galerie Schmela, Düsseldorf.

'Contemporary Spanish Artists', The Bundy Art Gallery, Waitsfield, Vt.

1966 Salon de Mai, Paris.

'Métaphysique de la matière', Palais des Beaux-Arts, Charleroi.

'Homage to Antonio Machado', The Spanish Refugee Aid, Inc., New York.

VI Biennale di Mentone, Menton.

'Spazio, forma e colore all'Università di San Gallo', Palazzo Ducale, Venice.

'Architektur und Kunst', Biel.

1967 7e Biennale Internationale d'Arts Graphiques, Ljubljana.

Salón de Mayo, Havana.

'Spanische Kunst der Gegenwart', Bochum, San Sebastian, Nuremberg, Berlin, Baden-Baden, Geneva, Copenhagen, Rotterdam.

1968 'European Painters Today', Musée des Arts Décoratifs, Paris (organized by the Arts Council of Great Britain).

Salon de Mai, Paris.

'Documenta VI', Kassel.

'L'Art vivant 1965–1968', Fondation Maeght, Saint-Paul-de-Vence.

XXXIV Mostra Biennale Internazionale d'Arte, Venice.

1969 Salon de Mai, Paris.

'Contemporary Art—Dialogue Between the East and the West', Museum of Modern Art, Tokyo.

'Artistes espagnols' (Gris, Picasso, Miró, Tàpies, Chillida), Galerie Beyeler, Basel.

8e Biennale Internationale d'Arts Graphiques, Ljubljana.

'Hartung, Tàpies, Johns, Hozo', Národní Galerie, Prague.

1970 'Acquisitions récentes du Centre National d'Art Contemporain', C.N.A.C., Paris.

The Pittsburgh International Exhibition of Contemporary Painting, Carnegie Institute, Pittsburgh.

1971 'Agora 1', A l'Ancienne Douane, Strasbourg.

Karl-Ernst-Osthaus Museum, Hagen, Germany.

Pretoria Art Museum, Pretoria, South Africa.

'ROSC '71. The Poetry of Vision', Dublin.

'EUROPA—AMERICA', Galerie Beyeler, Basel.

1972 XXXVI Mostra Biennale Internazionale d'Arte, Venice.

'Yo he venido ...' (lecture at the Universidad Internacional Menéndez y Pelayo, Santander, 1955). Published in *Cuadernos Hispano-Americanos*, No. 70, Madrid, 1955.

'Mano a mano' (interview), *La Vanguardia*, Barcelona, 5 December 1958.

Answers to a questionnaire of J.R. Menéndez in *Universidad*, No. 4 (11th year), Barcelona, 1959.

'Visto y oído' (interview), *Destino*, Barcelona, 13 February 1960.

'Conversaciones sobre arte actual' (interview), *El Noticiero*, Barcelona, 5 April 1961.

Text in the catalogue of 'Paintings in America 1959–60'', Gress Gallery and Martha Jackson Gallery, Washington and New York, 1961.

Answers to a questionnaire *(Marcel Proust)* of L. Permanyer, *Destino*, Barcelona, 29 December 1962.

Interview in *La Prensa*, Barcelona, 12 November 1963.

'Über mein Schaffen', catalogue of the exhibition at the Galerie Im Erker, St Gallen, 1963.

'Mosáico Parisiense' (interview), *La Vanguardia*, Barcelona, 31 May 1964.

'Rencontre avec Tàpies en quête de l'homme pur', remarks collected by Yvon Taillandier in an interview for *XXe Siècle*, No. 24, Paris, 1964.

*Arp*, catalogue of Hans Arp's exhibition at the Galerie Im Erker, St Gallen, 1966.

'El joc de saber mirar', in *Cavall Fort* (children's periodical of the 'Secretariats catequistes' of Gerona), Vich, Solsona, January 1967.

'Antoni Tàpies, testimoni', answers to a questionnaire of B. Porcel in *Serra d'or*, Montserrat Abbey, Barcelona, February 1967.

*La pràctica de l'art* (collection of 16 articles), Ariel, Barcelona, 1970.

Joan Brossa, *Tres aiguaforts*, Enric Tormo, Barcelona, 1949.

Cabral de Melo, preface to catalogue of exhibition at the Institut Français, Barcelona, 1949.

Arnaldo Puig, 'La encrucijada del arte', in *Dau al Set*, Barcelona, October, November, December 1949.

Joan Brossa, 'Oráculo sobre Antoni Tàpies', in *Dau al Set*, Barcelona, November 1950.

Joan José Tharrats, *Antoni Tàpies o el Dau Modern de Versalles*, Dau al Set, Barcelona, 1950.

Enric Jardí, *Antoni Tàpies*, Ariel, Barcelona, 1950.

Gordon B. Washburn, preface to catalogue of exhibition at the Martha Jackson Gallery, New York, 1953.

Alexandre Cirici-Pellicer, *Tàpies o la transverberació*, Dau al Set, Barcelona, 1954.

Michel Tapié, *Antonio Tàpies*, Dau al Set, Barcelona, 1955.

Joan Teixidor, *Entre les lletres i les arts*, Horta, Barcelona, 1957.

Jacques Dupin, preface to catalogue of exhibition at the Galleria dell' Ariete, Milan, 1958.

Franz Meyer, 'Tàpies, Alechinski, Messagier, Moser', preface to catalogue of exhibition at the Kunsthalle, Bern, 1959.

Michel Tapié, *Antonio Tàpies*, R.M., Barcelona, 1959.

Juan Eduardo Cirlot, *Tàpies*, Omega, Barcelona, 1960.

*Papeles de Son Armadans*, No. 57, Madrid/Palma de Mallorca, 1960. Special number devoted to Tàpies; texts by G.C. Argan, C.J. Cela, J. Teixidor, F. Bayl, J.A. Gaya Nuño, G. Habasque, A. Cirici-Pellicer, E. Westerdahl, V. Aguilera-Cerni, A. Puig, J. Miró, J. Prats Vallés, J. Brossa, A. Crespo, C.E. Ferreiro, A. Kerrigan, L. Moyà Gilabert, R. Santos Torroella, B. Bonet, M. Tapié, J.E. Cirlot, U. Apollonio, J. Dupin, F. Chueca Goitia, U. Kultermann, P. Restany, H. Read.

James Johnson Sweeny, *Tàpies: A Catalogue of Paintings in America 1959–1960*, Gress Gallery and Martha Jackson Gallery, Washington and New York, 1961.

Shuzo Takiguchi, 'Poetic Tribute to Tàpies', in *Mizue*, No. 677, Tokyo, 1961.

Yoshiaki Tono, 'Antonio Tàpies', *ibid.*

Keizo Kanki, 'Catalonia and Tàpies', *ibid.*

Juan Eduardo Cirlot, *Significación de la pintura de Tàpies*, Seix Barral, Barcelona, 1962.

Lorenza Trucchi, preface to catalogue of exhibition at the Galleria Il Segno, Rome, 1962.

Werner Schmalenbach, 'Tàpies', preface to catalogue of exhibition at the Kestner-Gesellschaft, Hanover, 1962.

Lawrence Alloway, 'Antoni Tàpies', preface to catalogue of exhibition at The Solomon R. Guggenheim Museum, New York, 1962.

Eduard Hüttinger, 'Antonio Tàpies', preface to catalogue of exhibition at the Kunsthaus, Zurich, 1962.

Martha Jackson, preface to catalogue of exhibition at the Martha Jackson Gallery, New York, 1963.

Hans Platschek, preface to catalogue of exhibition at the Galerie Im Erker, St Gallen, 1963.

Jacques Dupin, 'Antonio Tàpies, papiers et cartons', text to catalogue of exhibition at the Galerie Berggruen, Paris, 1963.

Joan Teixidor, *Antoni Tàpies. Fustes, papers, cartons i collages*, Sala Gaspar, Barcelona, 1964.

Blai Bonet, *Tàpies*, La Polígrafa, Barcelona, 1964.

Alexandre Cirici-Pellicer, *Tàpies (1954–1964)*, Gustavo Gili, Barcelona, 1964 (English edition: Methuen, London, 1965).

François Pluchart, 'Métaphysique de la matière', preface to catalogue of exhibition at the Galerie Stadler, Paris, 1964.

Carlos Antonio Arean, Tàpies, Cacharrería del Ateneo, Madrid, 1964.

Roland Penrose, preface to catalogue of exhibition at the Institute of Contemporary Arts, London, 1965.

François Pluchart, preface to catalogue of exhibition at the Galerie Jacques Verrière, Cannes, 1966.

José M. Moreno Galván, 'La pintura de Tàpies: notas para empezar a escribir', preface to catalogue of exhibition at the Galería Biosca, Madrid, 1966.

Michel Tapié, preface to catalogue of exhibition at the Galerie Stadler, Paris, 1966.

Dan Evans, preface to catalogue of exhibition at the Martha Jackson Gallery, New York, 1967.

Giuseppe Gatt (ed.), *Antoni Tàpies*, Capelli, Bologna, 1967. Contributions by G. C. Argan, R. Barilli, M. Calvezi, F. Menna, N. Ponente, I. Tomassoni.

Francesco Vicens, *Antoni Tàpies. L'escarnidor de Diadems*, La Polígrafa, Barcelona, 1967.

Michel Tapié, 'Avec Antoni Tàpies', text to catalogue of exhibition at the Galerie Maeght, *Derrière le miroir*, No. 168, Paris, 1967.

Jacques Dupin, 'Devant Tàpies', *ibid.*

Werner Hofmann, 'Intra muros', preface to catalogue of exhibition at the Museum des 20. Jahrhunderts, Vienna, 1968.

Hans Platte, preface to catalogue of exhibition at the Kölnischer Kunstverein, Cologne, 1968.

Pierre Volboudt, 'La matière et ses doubles', text to catalogue of exhibition at the Galerie Maeght, *Derrière le miroir*, No. 175, Paris, 1968.

Joan Brossa, text to catalogue of exhibition at the Galerie Maeght, *Derrière le miroir*, No. 180, Paris, 1969.

Carlos Franqui, preface to catalogue of exhibition at the Galleria dell' Ariete, Milan, 1970.

Alexandre Cirici, *Tàpies. Testigo del Silencio/Témoin du Silence/Zeuge des Schweigens/Witness of Silence*, La Polígrafa, Barcelona, 1970.

The bibliography of Tàpies's work is by now too extensive to list in full here. For further references see Giuseppe Gatt (ed.), *Antoni Tàpies* (Capelli, Bologna, 1967), which contains an extensive bibliography. Most of the biographical and bibliographical data in the present work have been taken from this source.

Photo Credits

The Solomon R. Guggenheim Museum, New York: 35
Walter Klein, Düsseldorf: 33
Galerie Maeght, Paris: 49
Foto Mas, Barcelona: 18, 19, 20, 21, 26, 27, 28, 29, 32, 34, 36, 38, 39, 42, 43, 44, 45, 46, 47, 48, 50, 51, 54, 55, 56, 58, 59, 60, 61, 62, 66

The publishers are grateful to the Museum des 20. Jahrhunderts, Vienna, for the loan of the blocks for the colour reproductions on the jacket and on pages 23, 37 and 57.

GARDNER WEBB COLLEGE LIBRARY.

ND      Tapies Puig,
813        Antonio, 1923-
T3
L5613  Tapies

| DATE | | | |
|------|--|--|--|
| JAN. 27 1988 | | | |
| MAR 2 0 1998 | | | |
| | | | |
| | | | |
| | | | |
| | | | |
| | | | |
| | | | |
| | | | |
| | | | |

DO NOT DISCARD.  Indexed in
World Painting Index

REF ND 45 H38

© THE BAKER & TAYLOR CO.